Smithsonian

CABINET of CURIOSITIES

Over 1,000 Curated Stickers from the
Fascinating Collections of the
Smithsonian

Andrews McMeel
PUBLISHING®

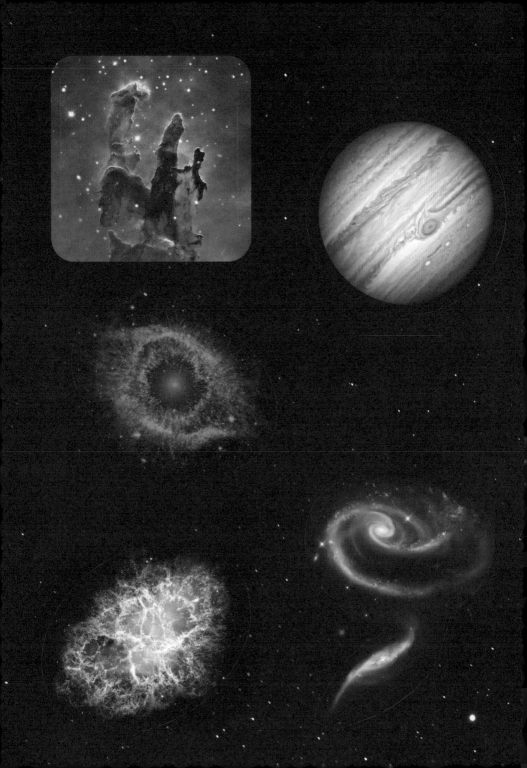

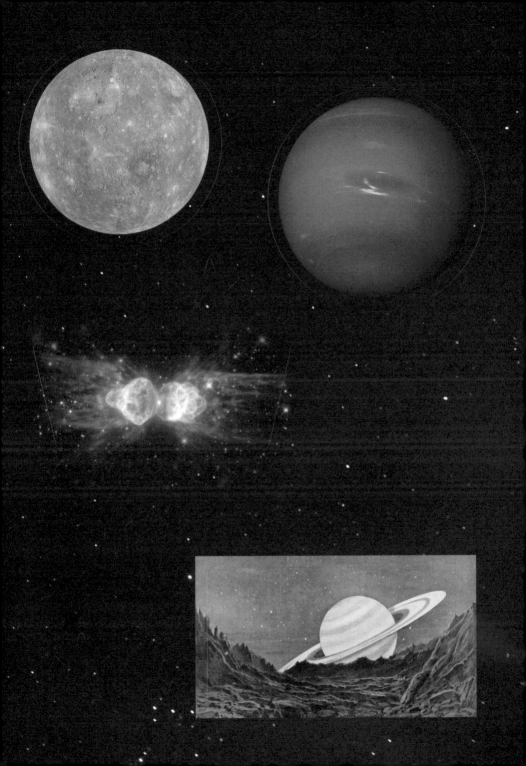

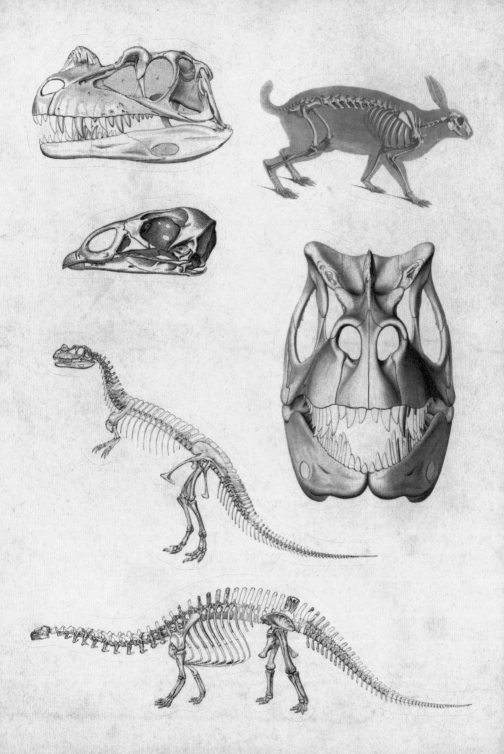

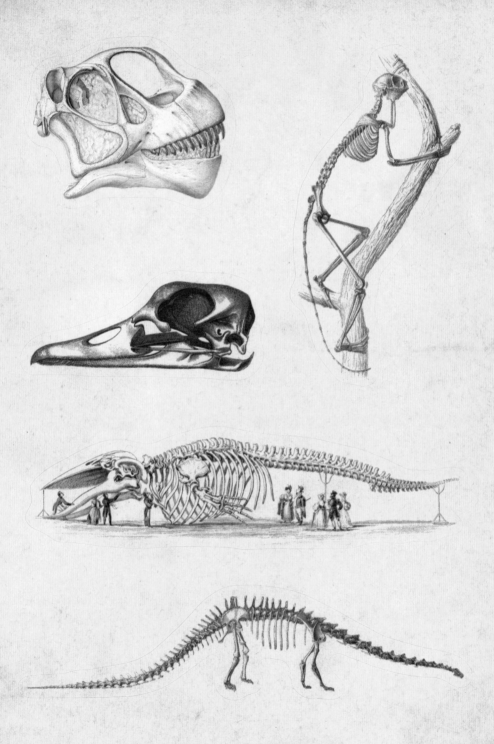

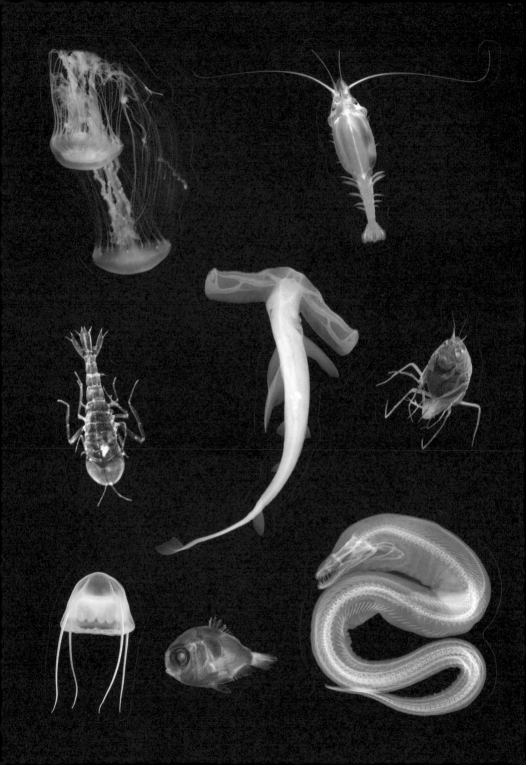

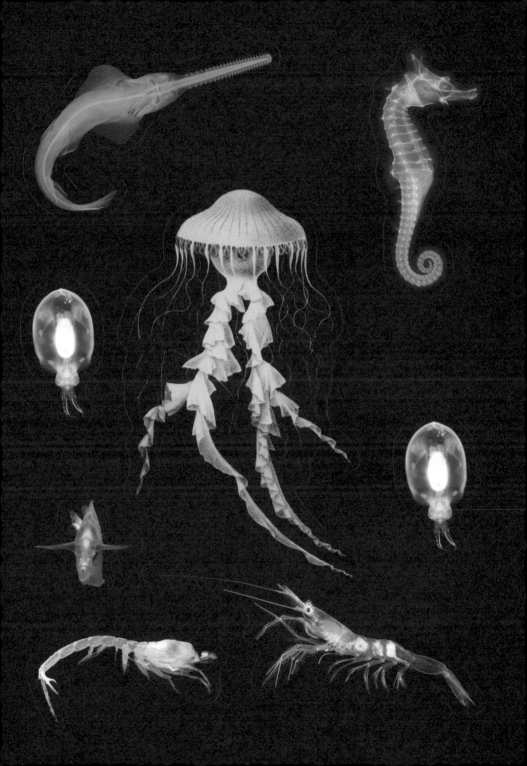

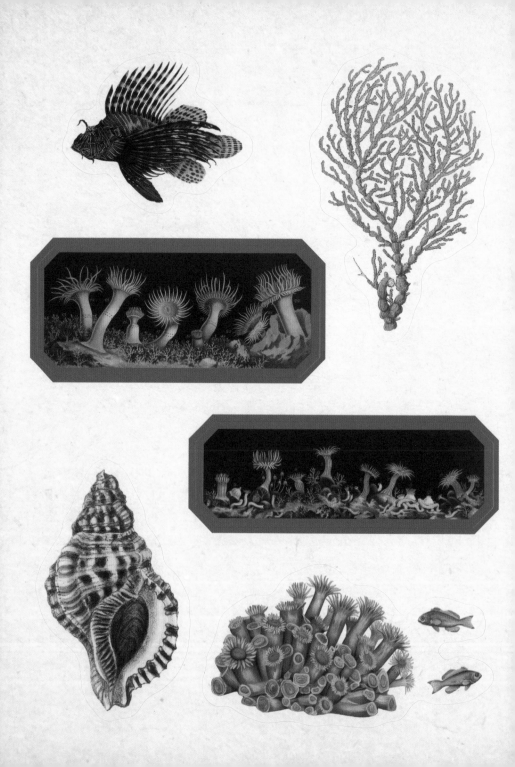

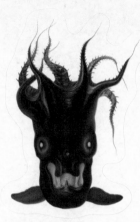
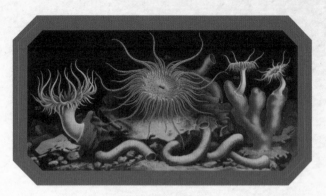

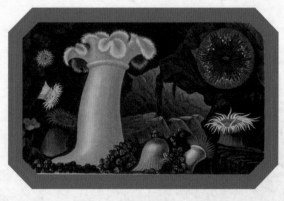

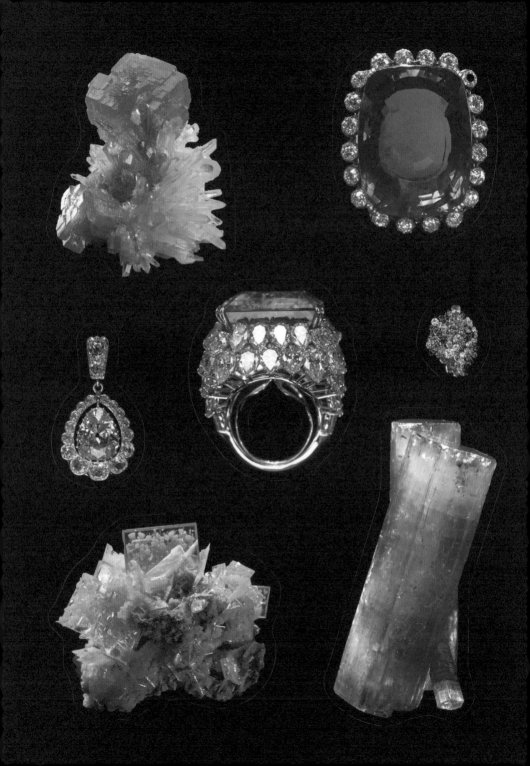

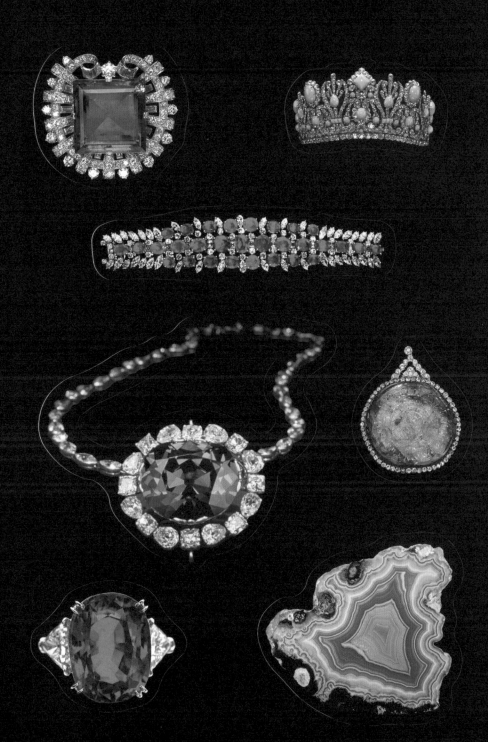

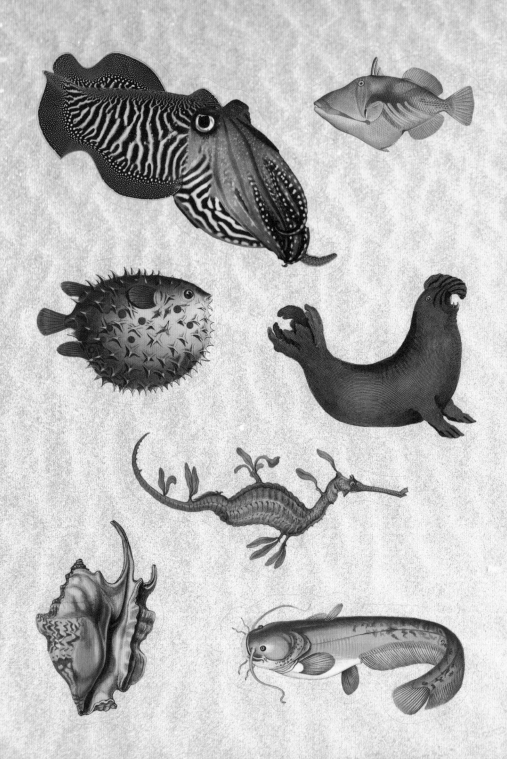

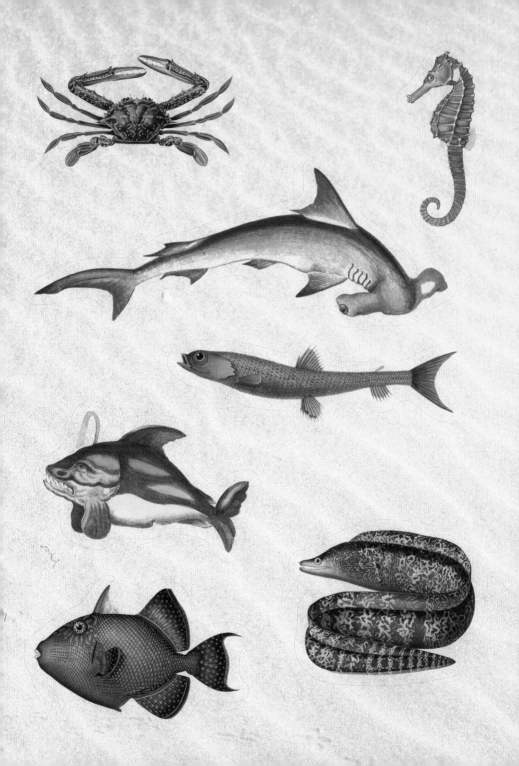

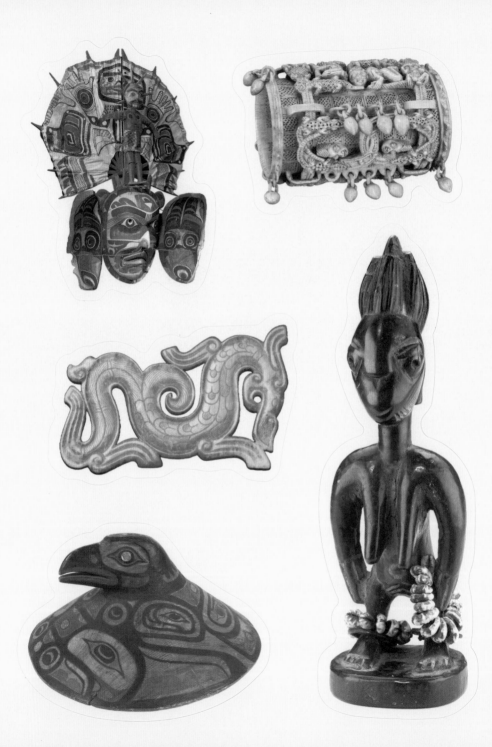

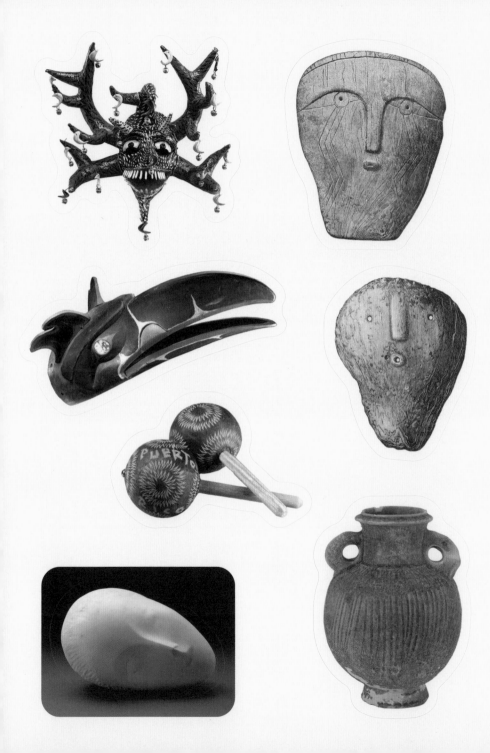

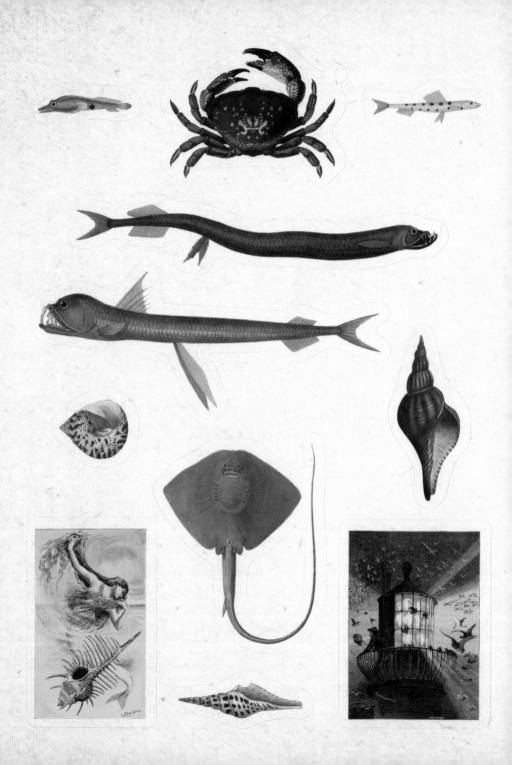

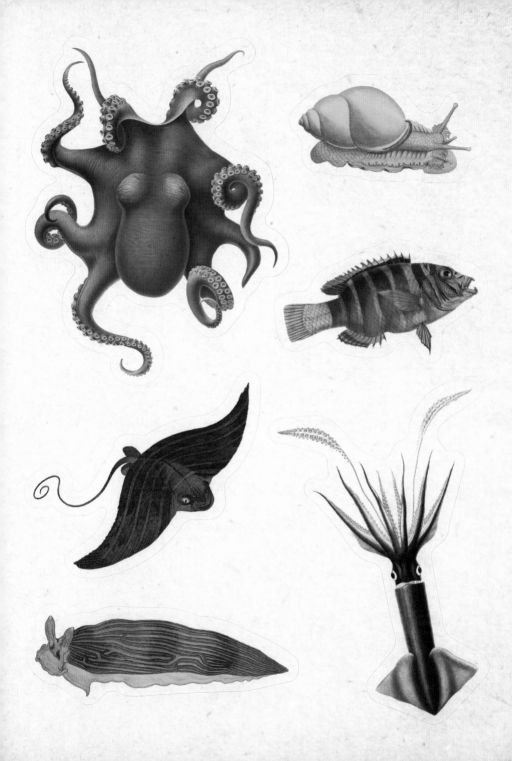

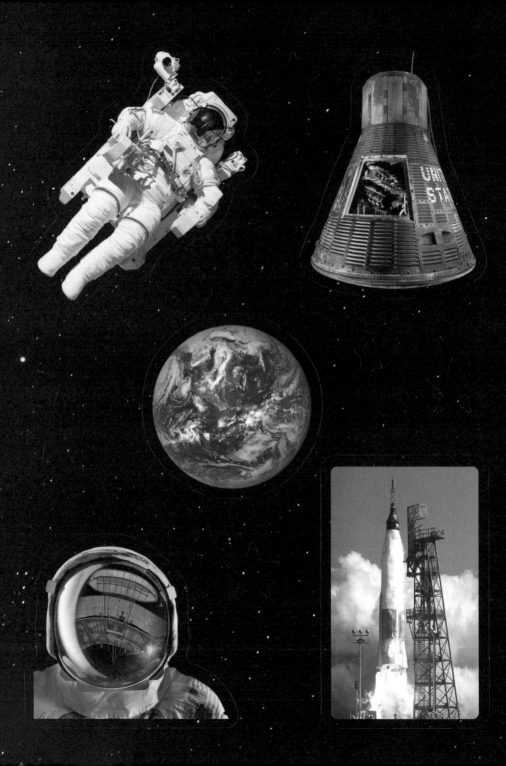

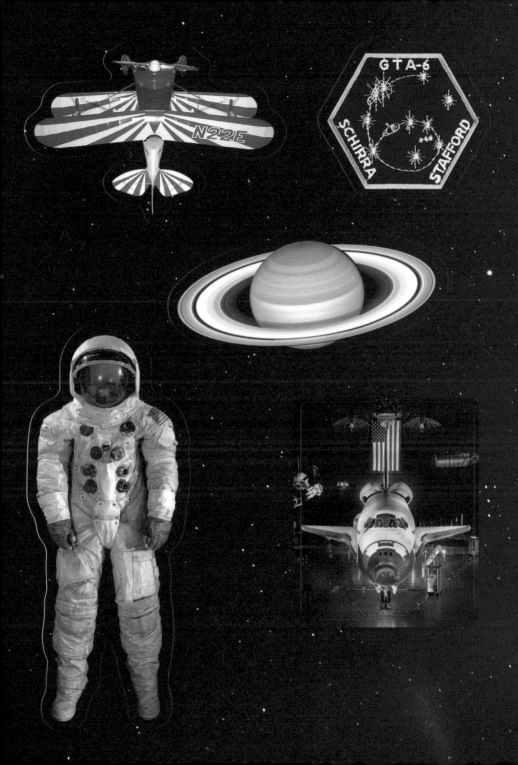

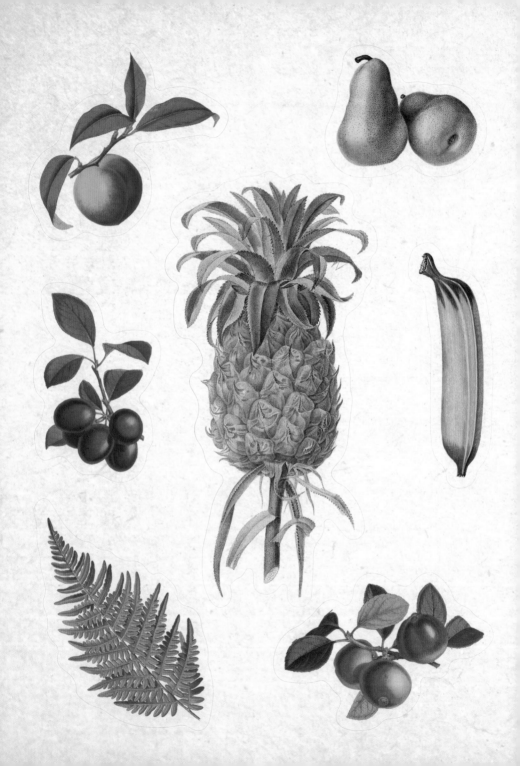

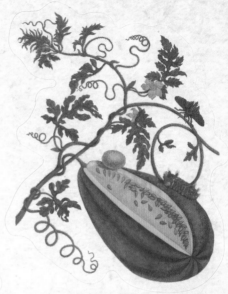

MILLS'
SEED CATALOGUE
1909

A
UNIQUE NOVELTY
ORNAMENTAL
AND USEFUL

SEE DESCRIPTION
NEXT PAGE

"MEXICAN BOUQUET PEPPER"
(FROM PHOTO)

PAT SC. 3 PKTS 20C
6 PKTS. 35C

F.B.MILLS CO. SEEDSMEN, WASHINGTON, IOWA

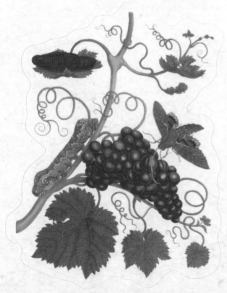

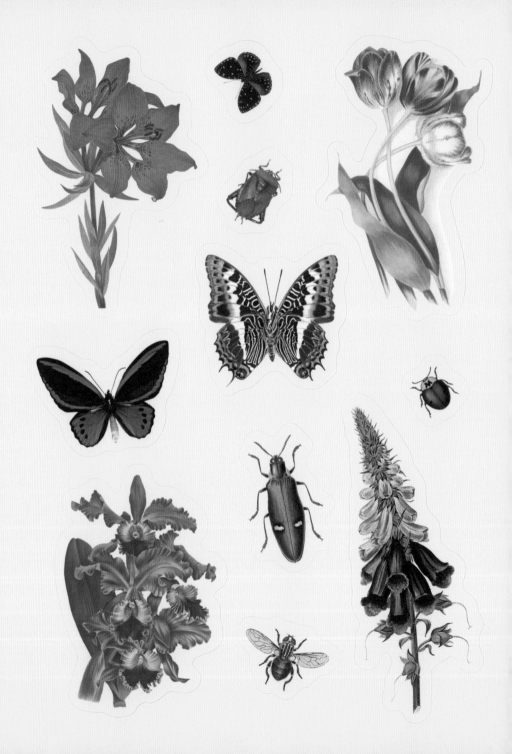

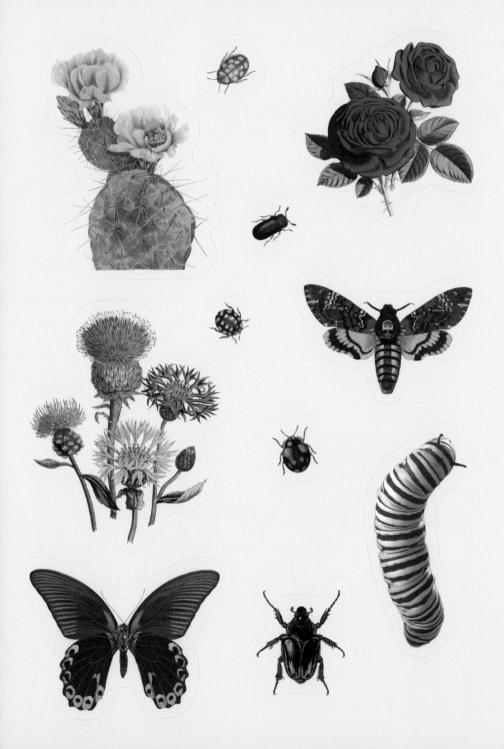

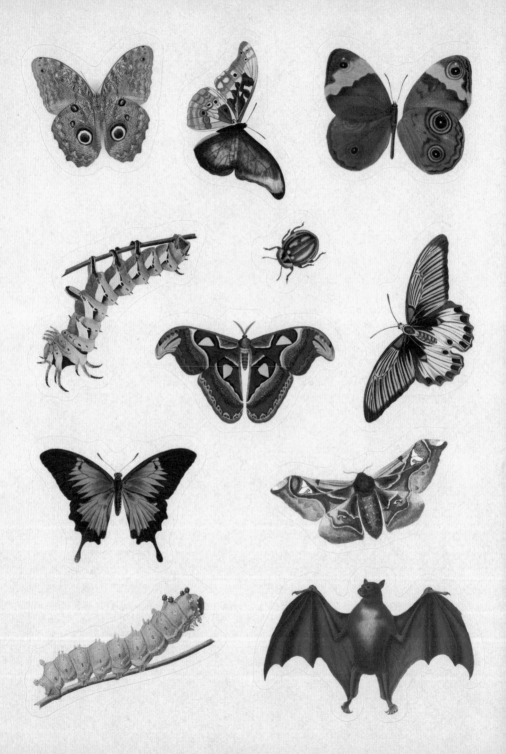

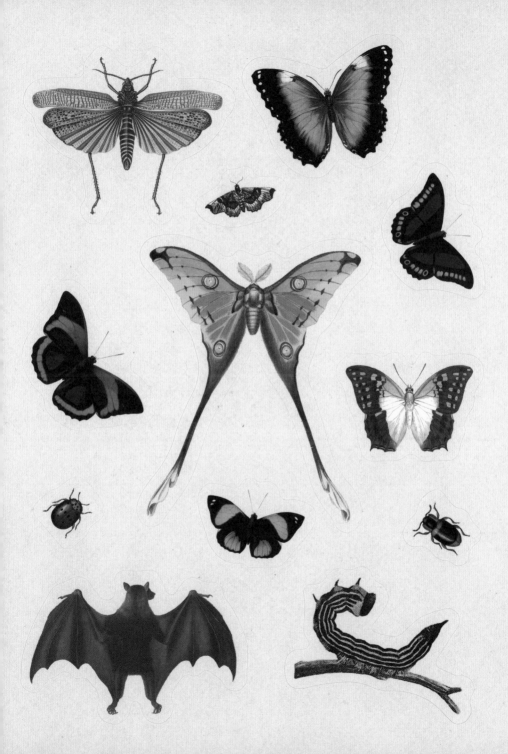

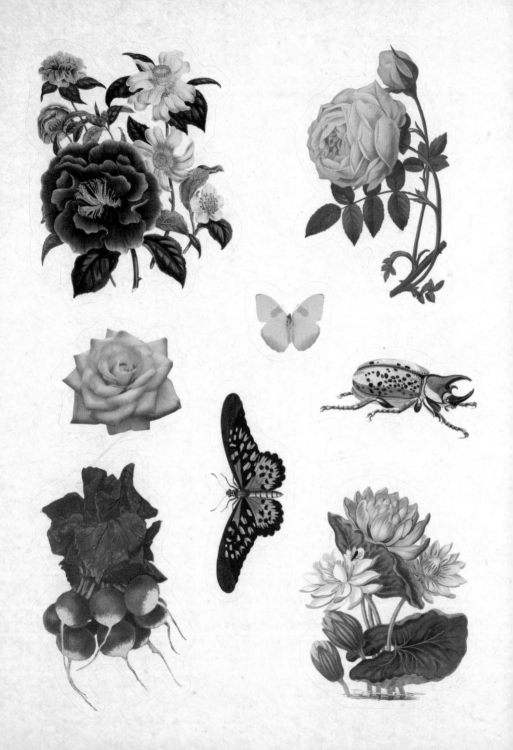

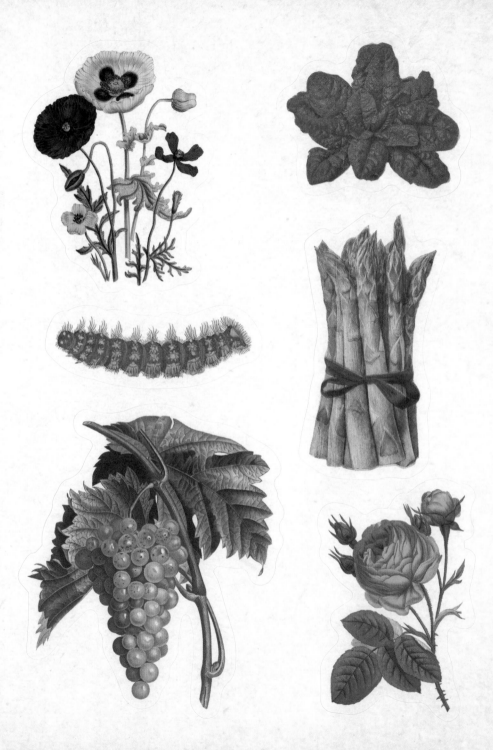

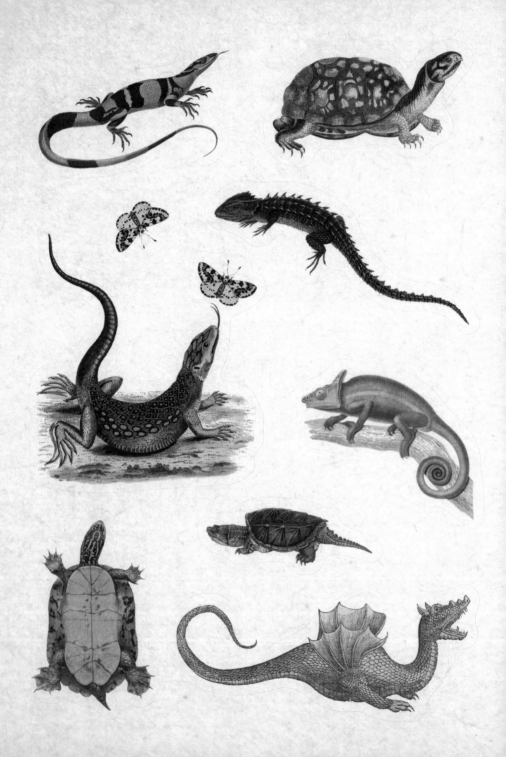

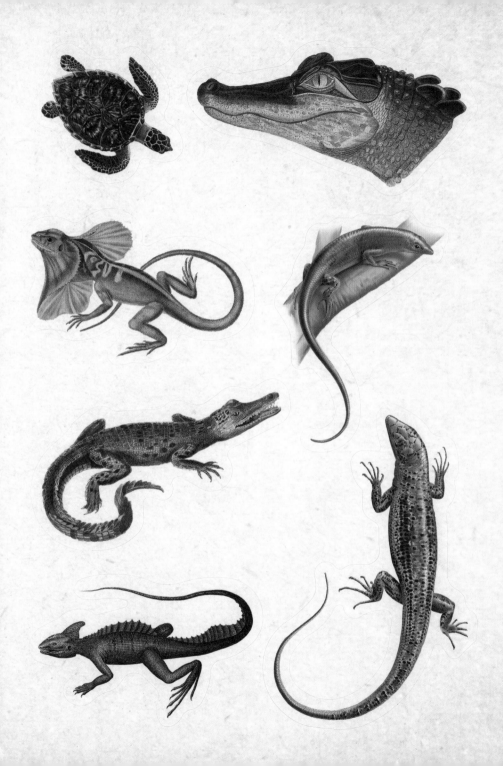

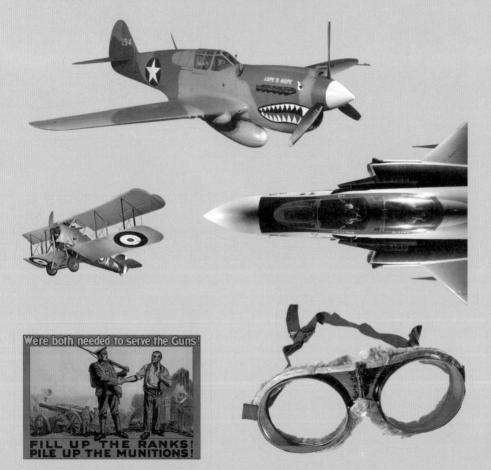

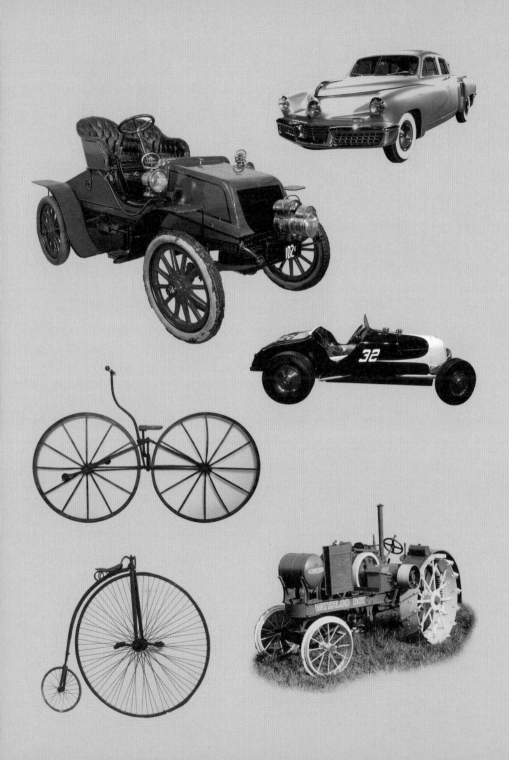

FLOWERS·FROM·
SHAKESPEARE'S·GARDEN.
a Posy from the Plays, pictured by Walter Crane

Cassell & Co. Ltd 1909

But sweeter than the lids of Juno's eyes

violets dim.

"Or Cytherea's breath;

That die unmarried, ere they can behold
Bright Phoebus in his strength, a malady
Most incident to maids;

pale primroses

The crown · · imperial;

lilies of all kinds,

The flower-de-luce being one."

"Here's flowers for you,

"Hot lavender.

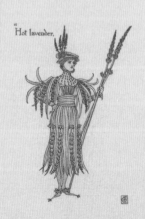

The marigold that goes to bed with the sun,
And with him rises weeping;

Winter's Tale
Act IV. Sc. III.

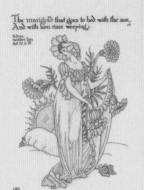

"Their lips were four red roses on a stalk,
Which in their summer beauty kissed each other"

Richard III. Act IV. Sc. 3.

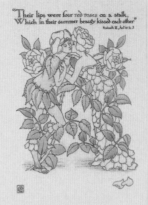

"Enter OPHELIA,
fantastically dressed with straws and flowers."

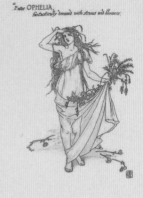

"There's rosemary,
that's for remembrance;

— There's a daisy: —

Hamlet. Act IV. Sc. VI.

"CERES, most bounteous lady, thy rich lees
Of wheat, rye, barley,"

Tempest Act IV. Sc. I.

" The female ivy so
Enrings the barky fingers of the elm "

Midsummer Night's Dream
Act V. Sc. 2.

"If reasons were as plentiful as blackberries"

1 Henry IV. Act 2. Sc. 4.

Prerogative of age, crowns, sceptres, laurels

Troilus & Cressida. Act I. Sc. 3.

Finis

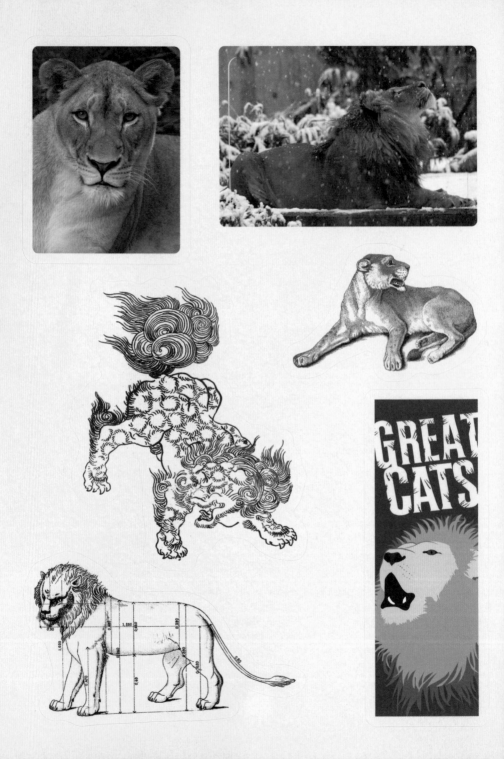

GREAT
CATS

Smithsonian
National Zoological Park

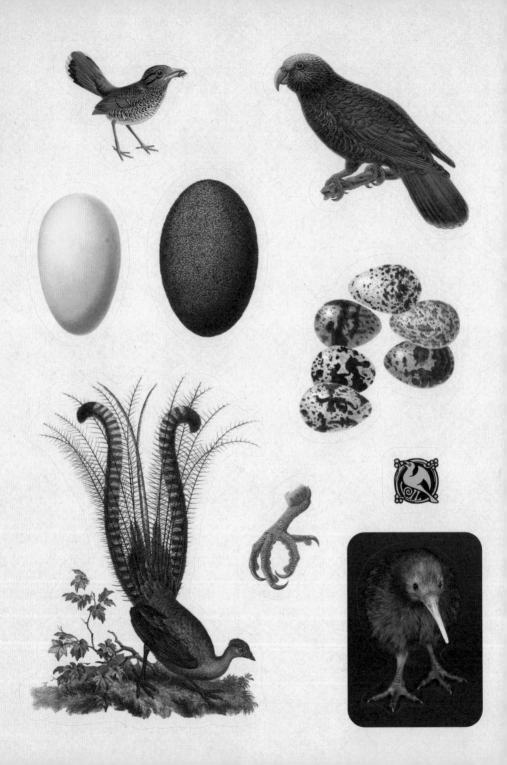

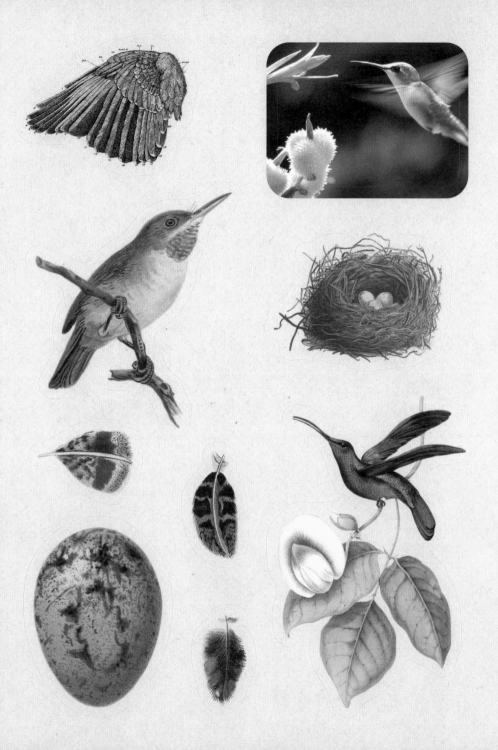

Smithsonian
National Zoological Park

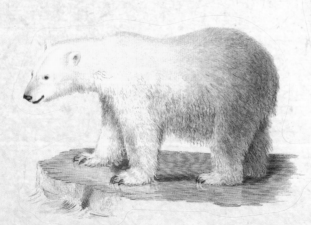

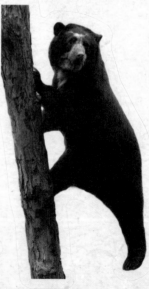

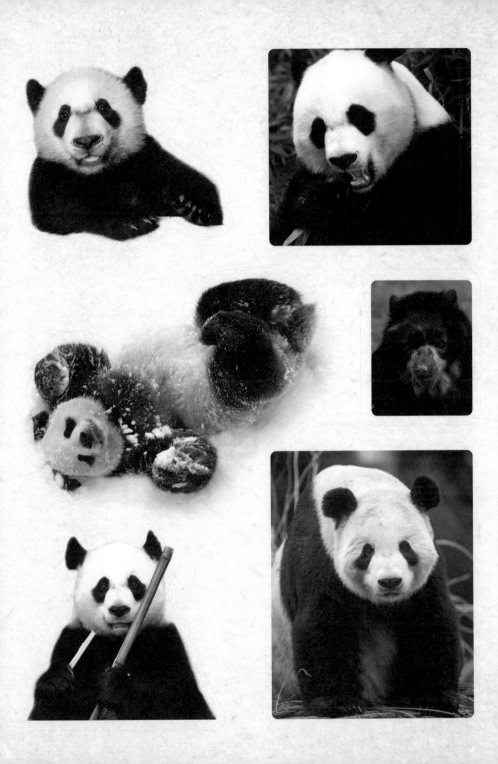

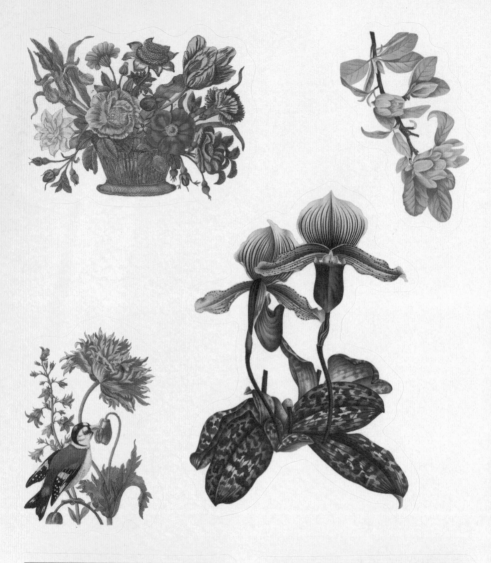
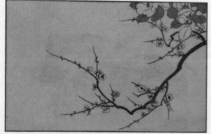
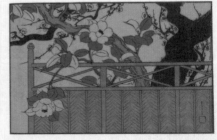

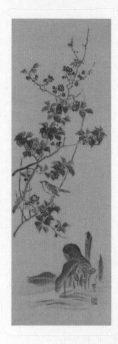
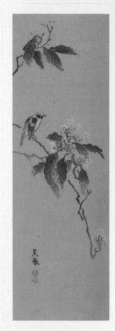
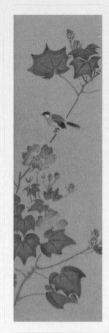
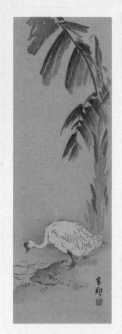
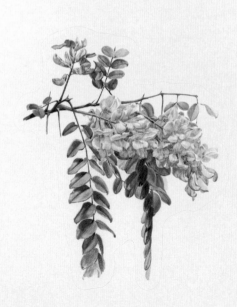

GOLDEN
LION
TAMARINS

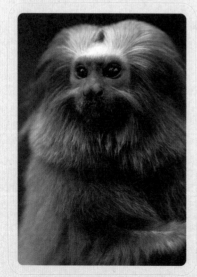

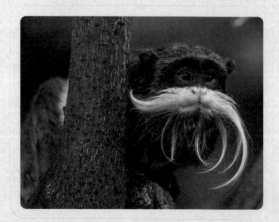

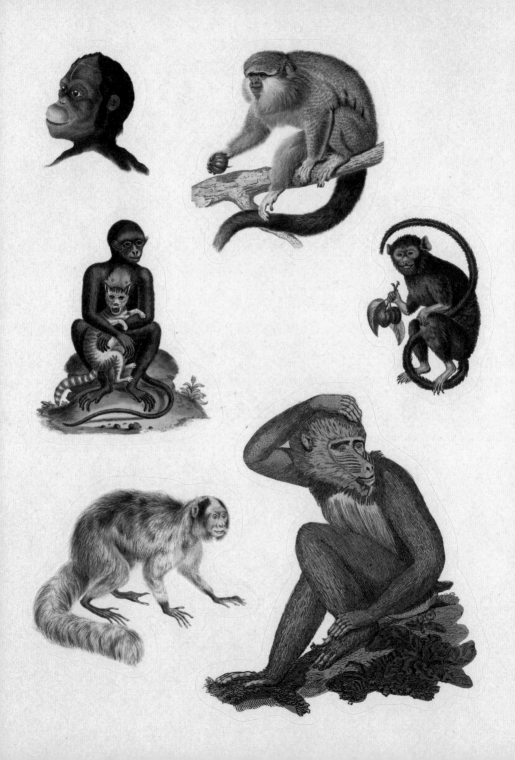

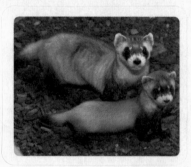
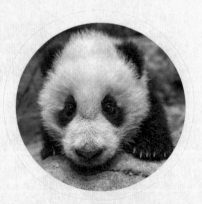
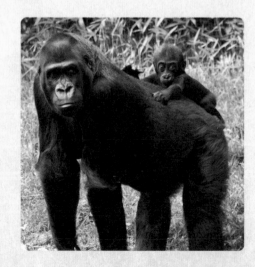

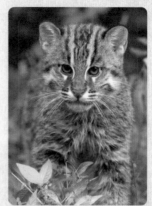

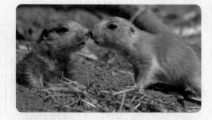

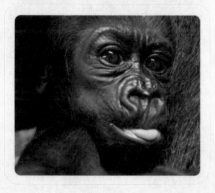

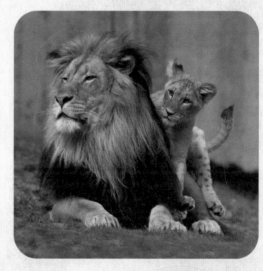

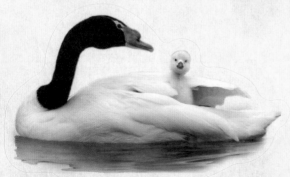

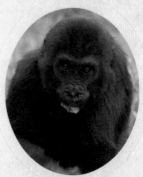

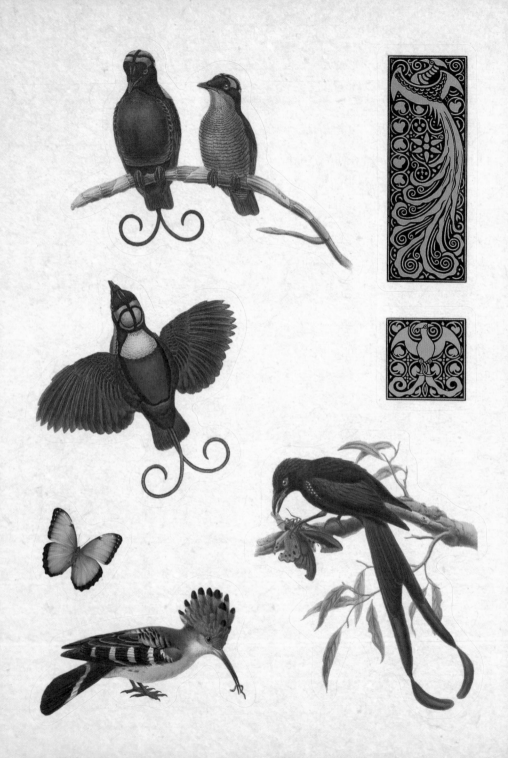

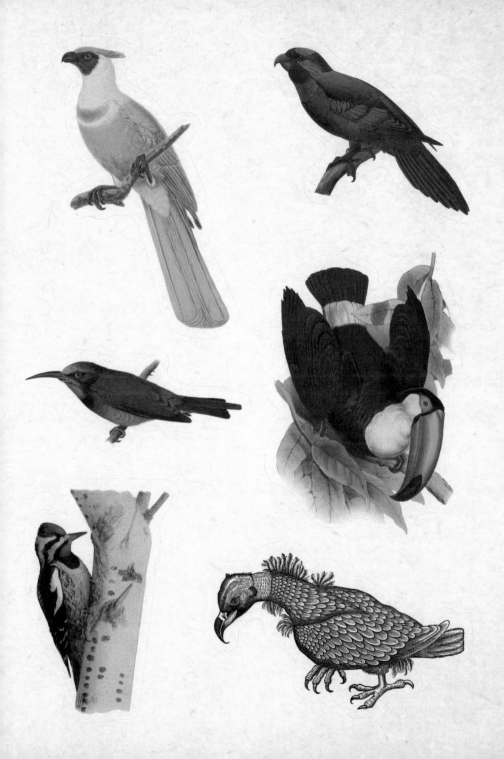

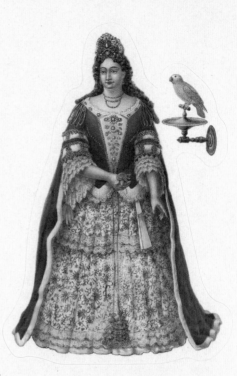

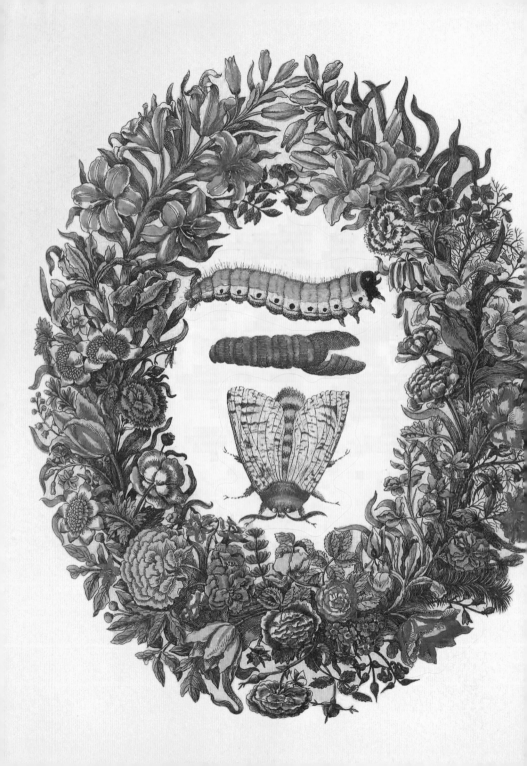

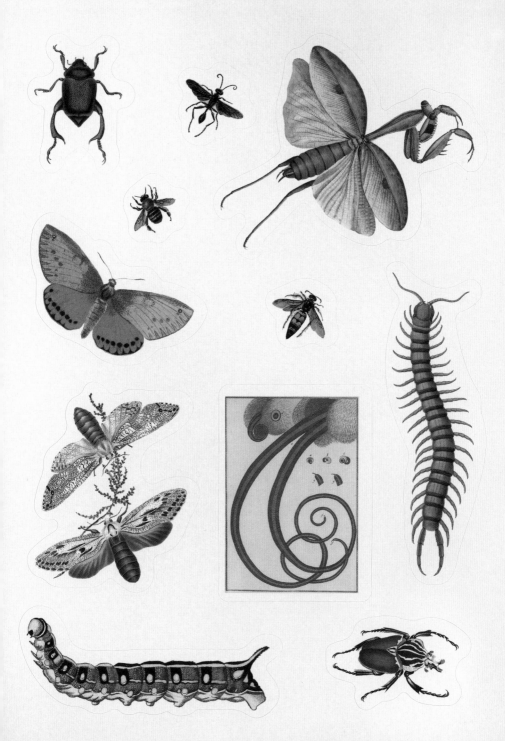

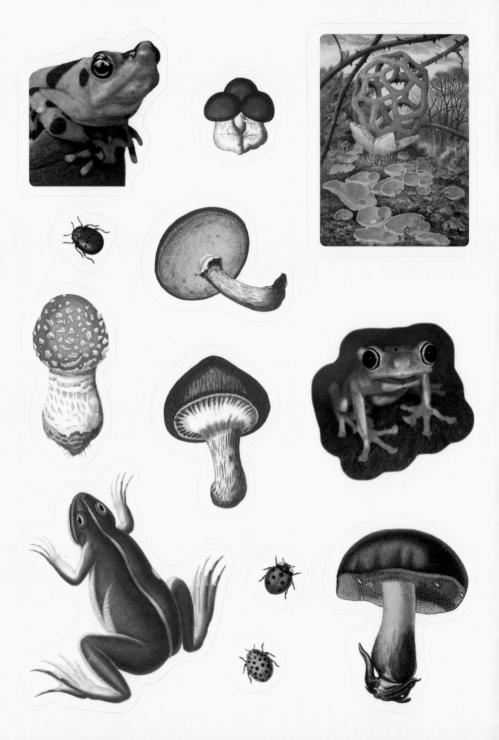

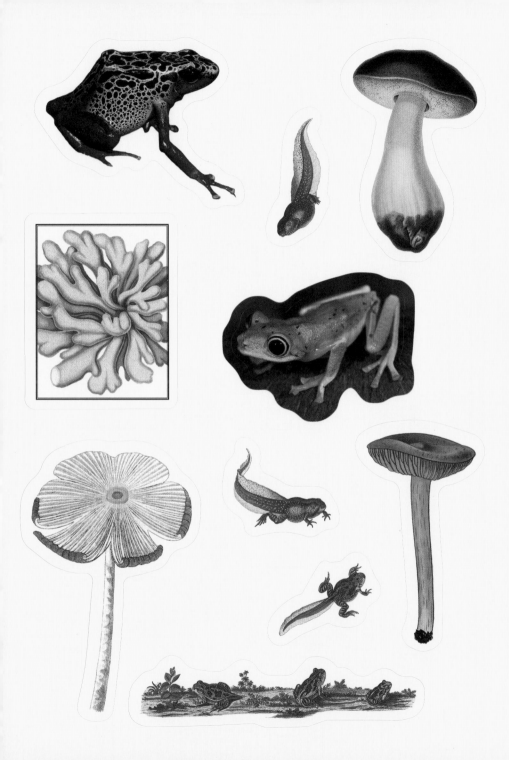

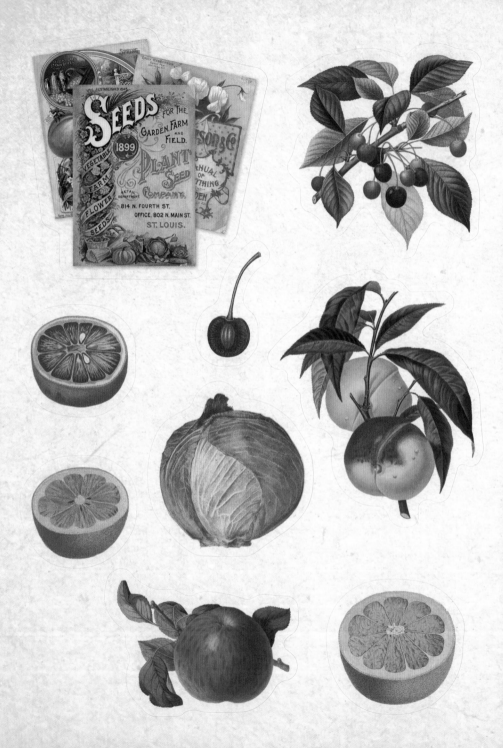

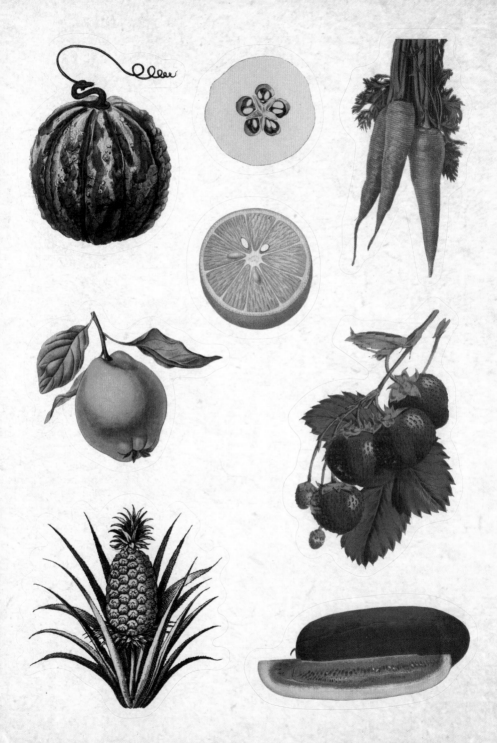

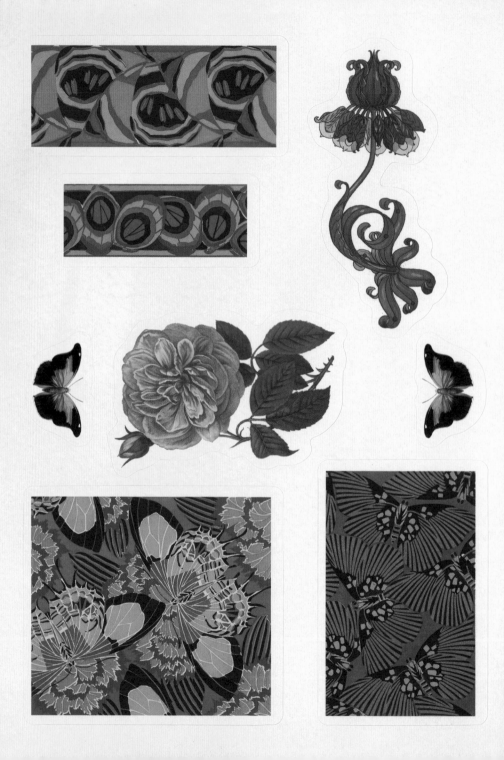

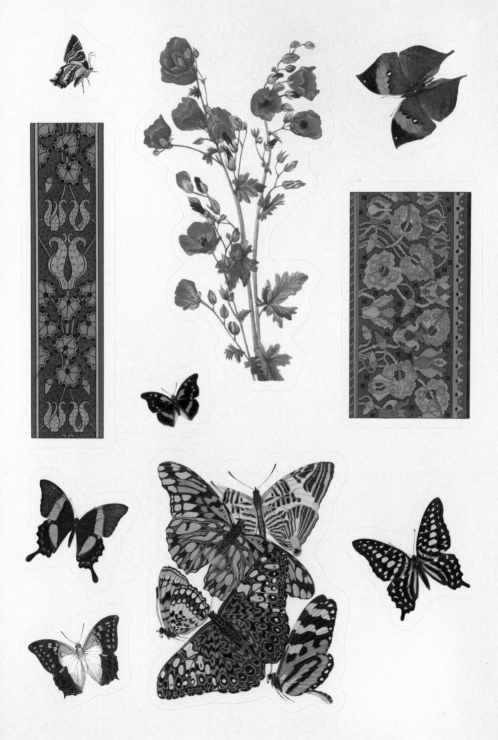

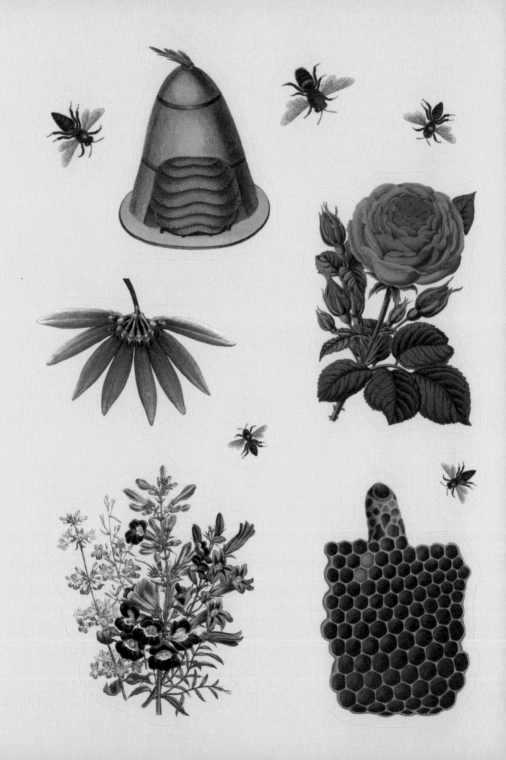

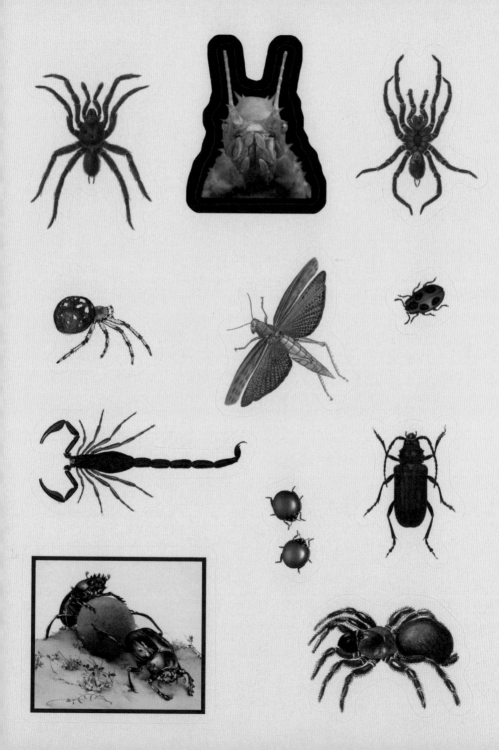

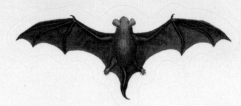

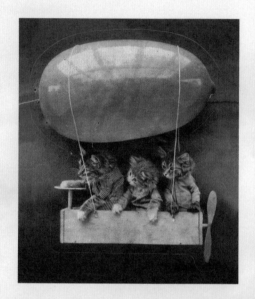

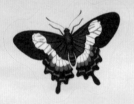

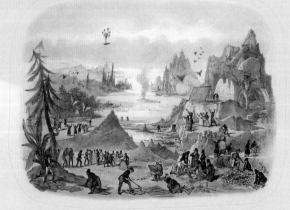

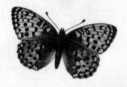
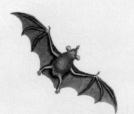
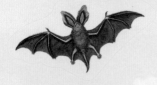
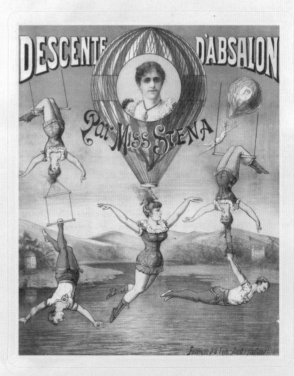

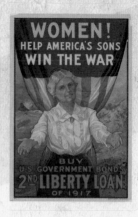

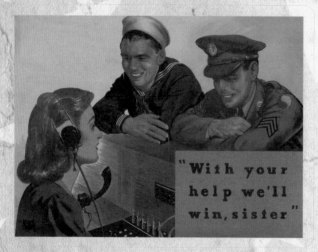

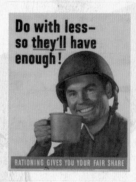

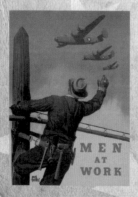

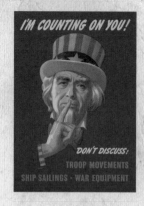

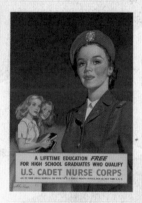

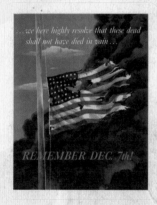

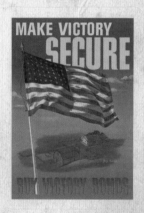

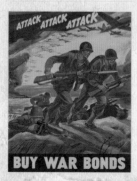

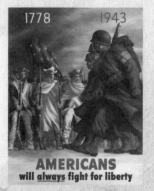

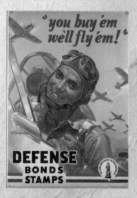

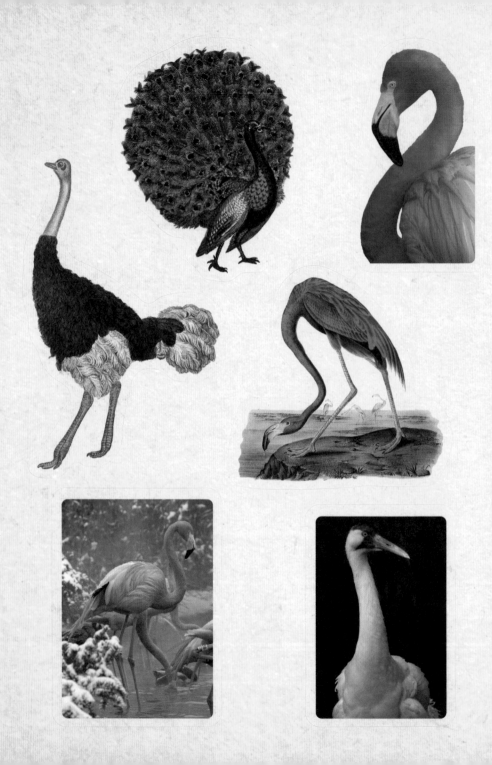

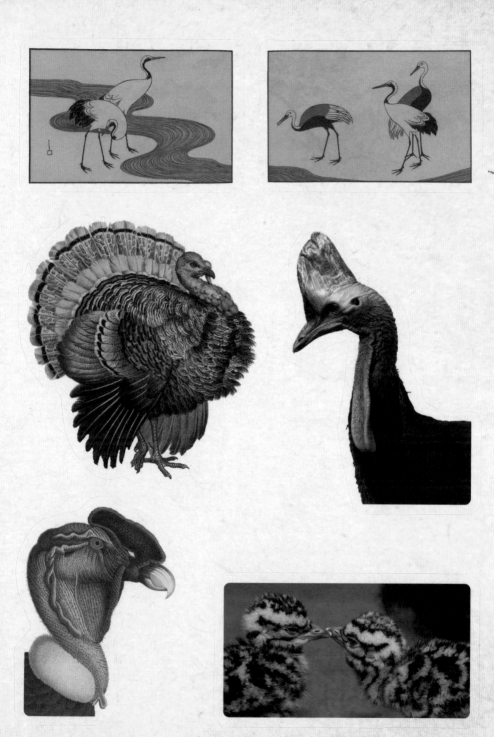

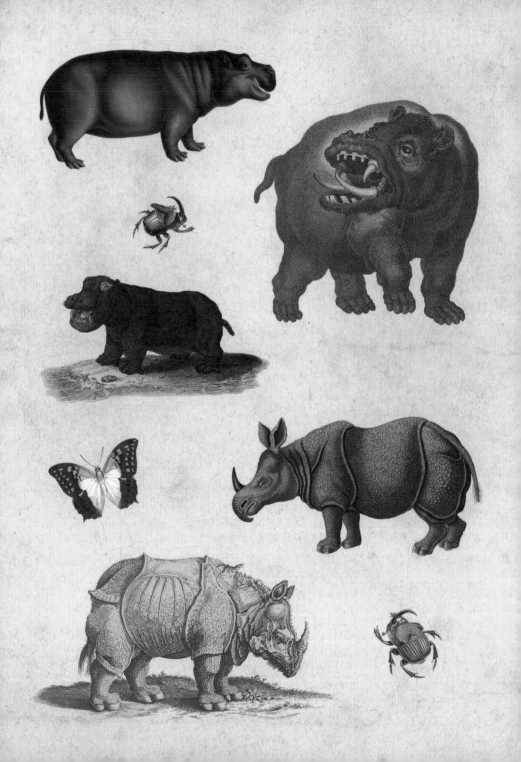

Smithsonian
*National
Zoological
Park*

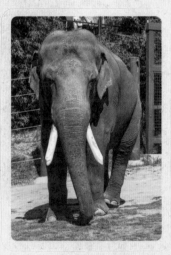

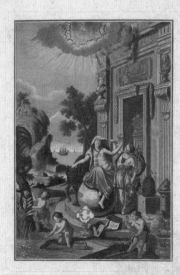

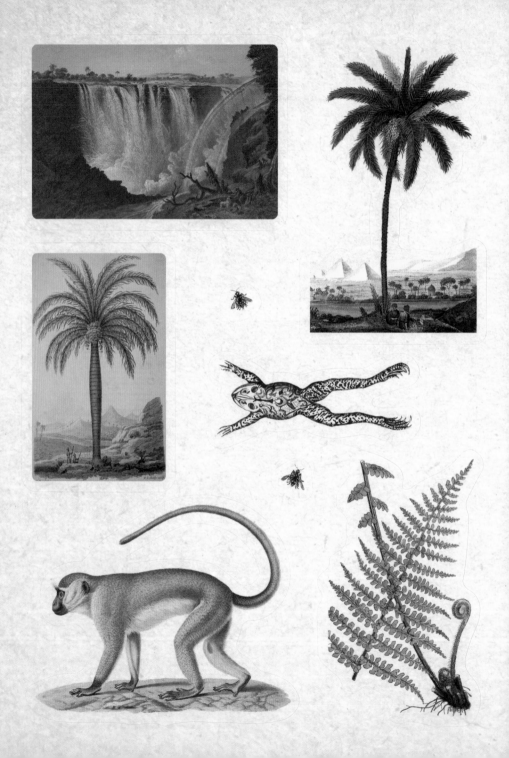

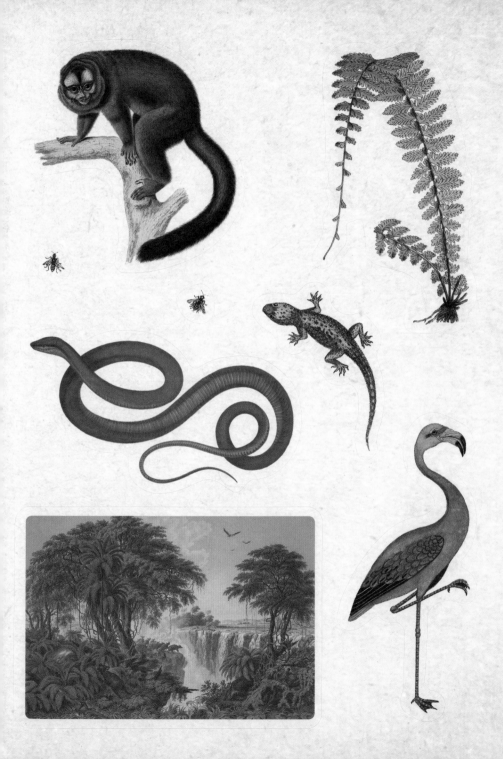

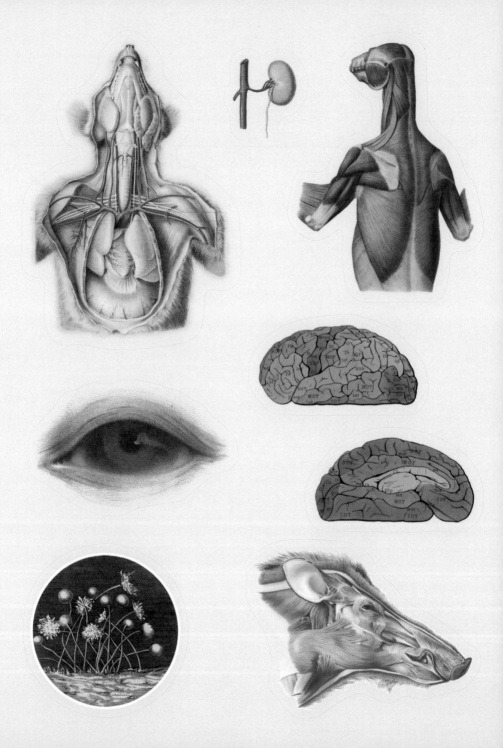

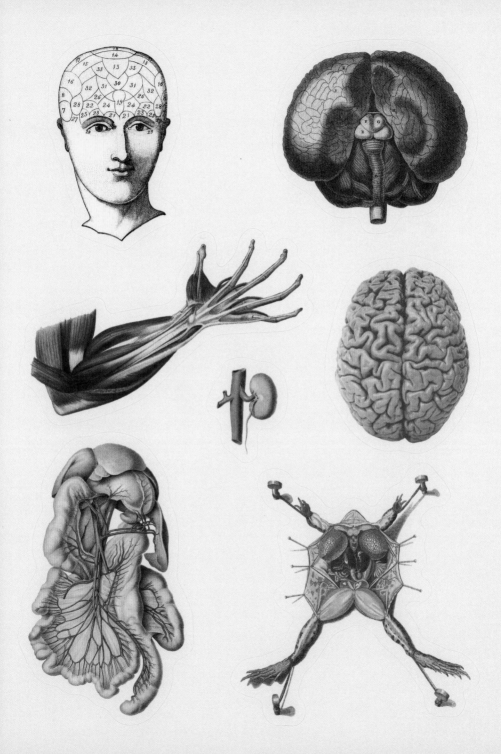

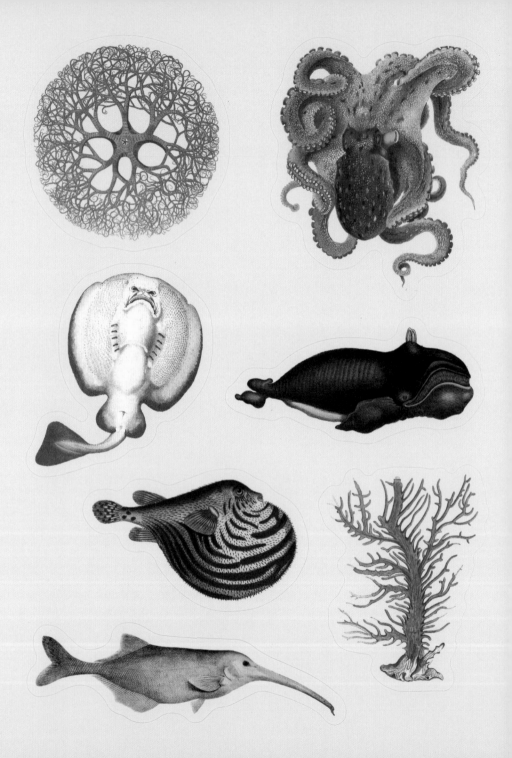

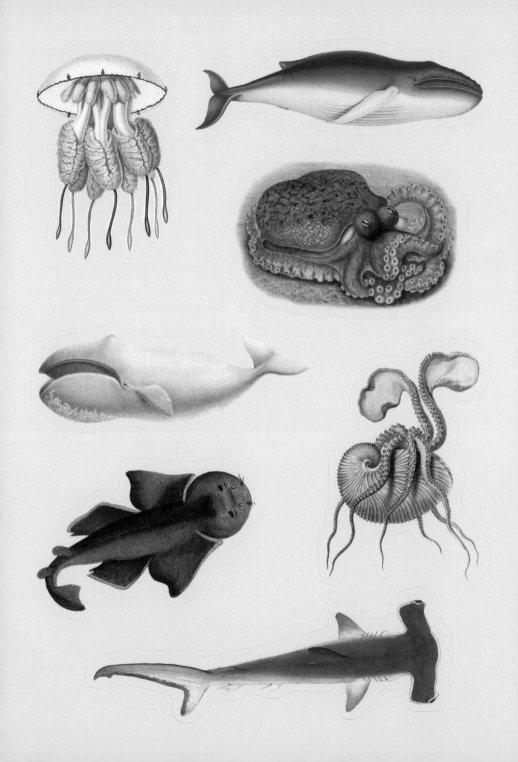

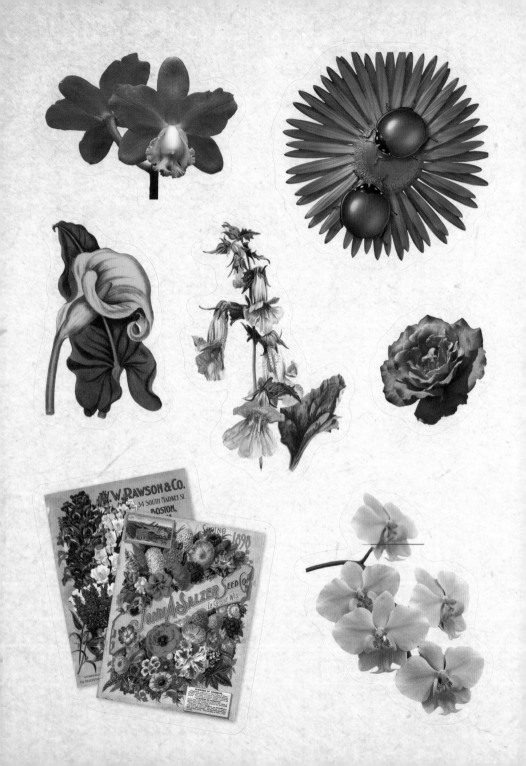

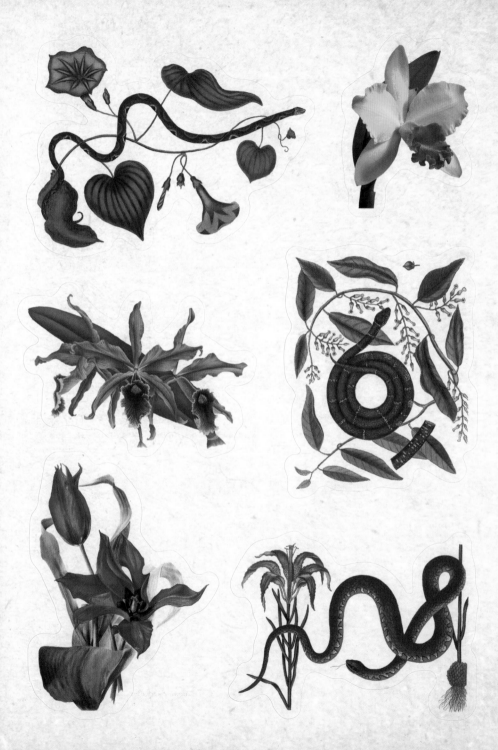

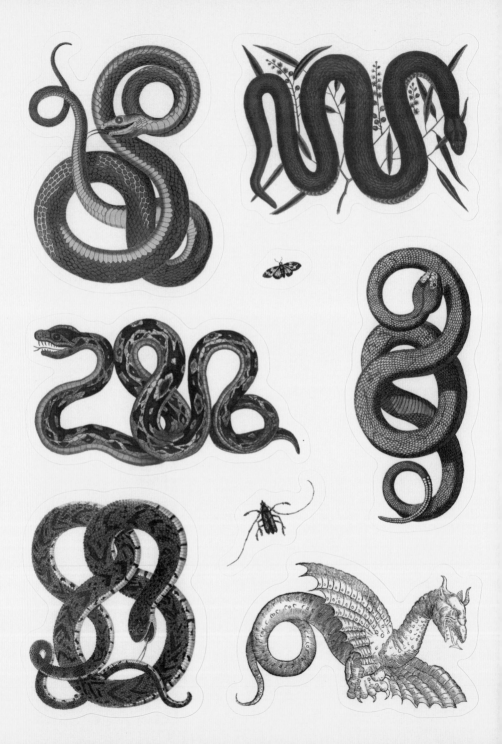

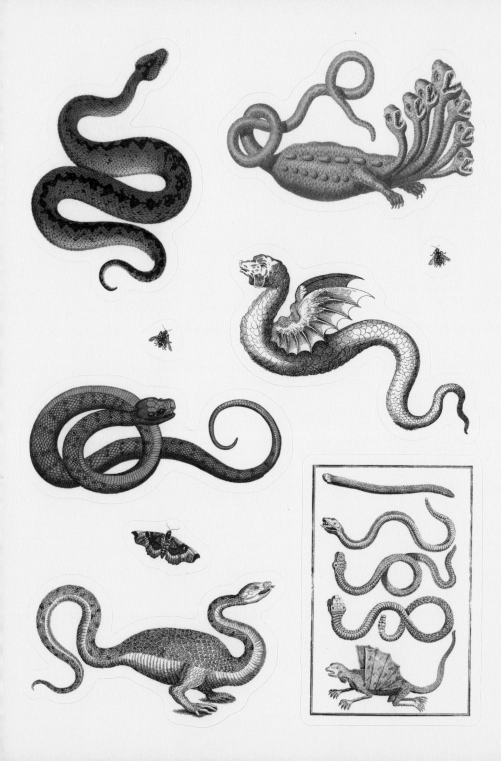

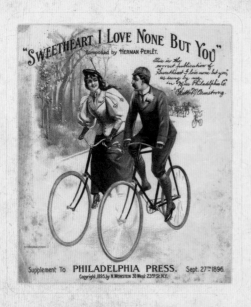

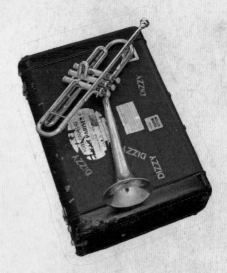

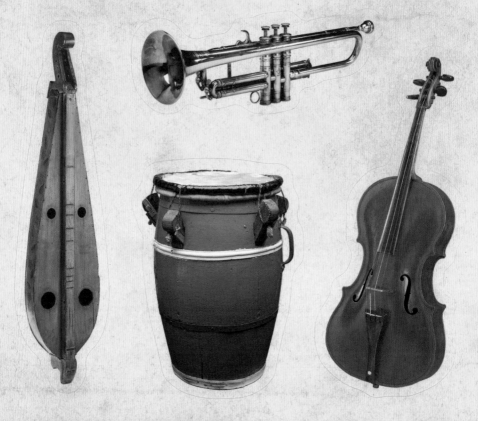

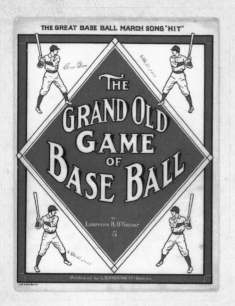

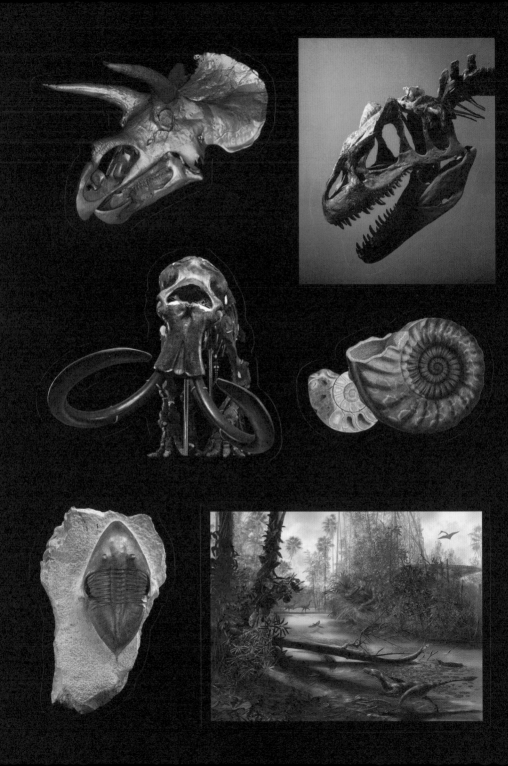

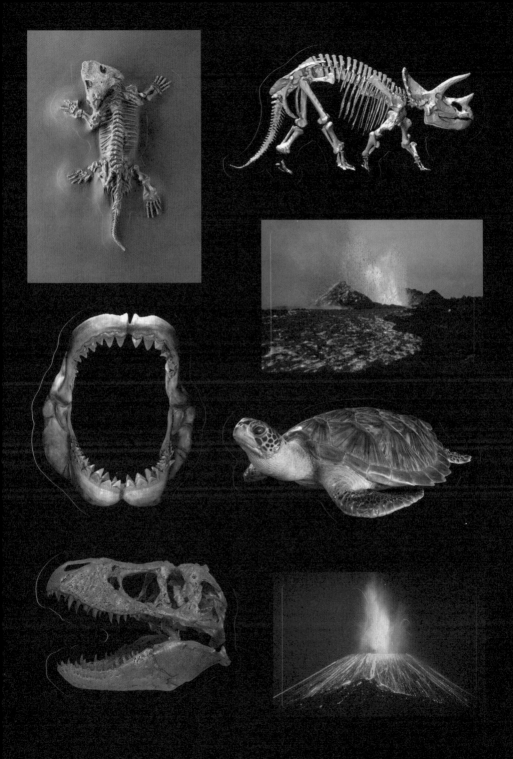

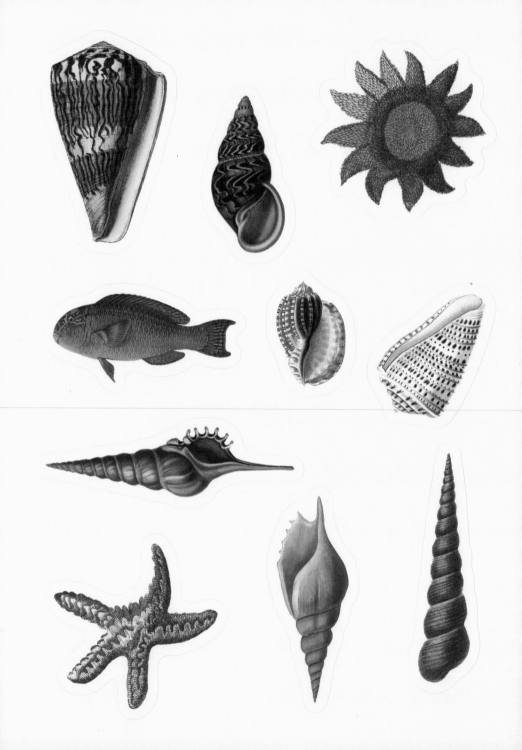

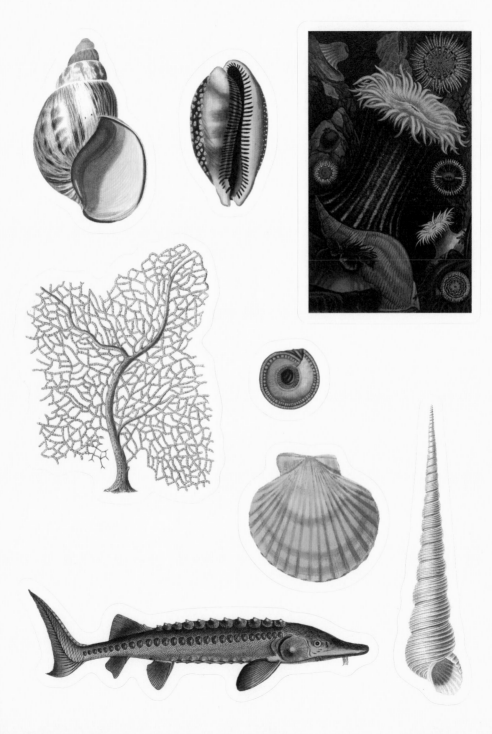

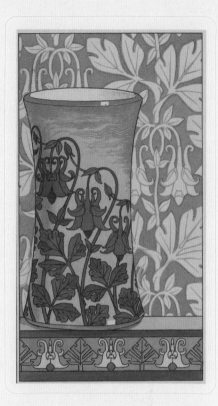

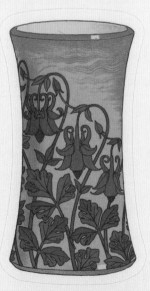

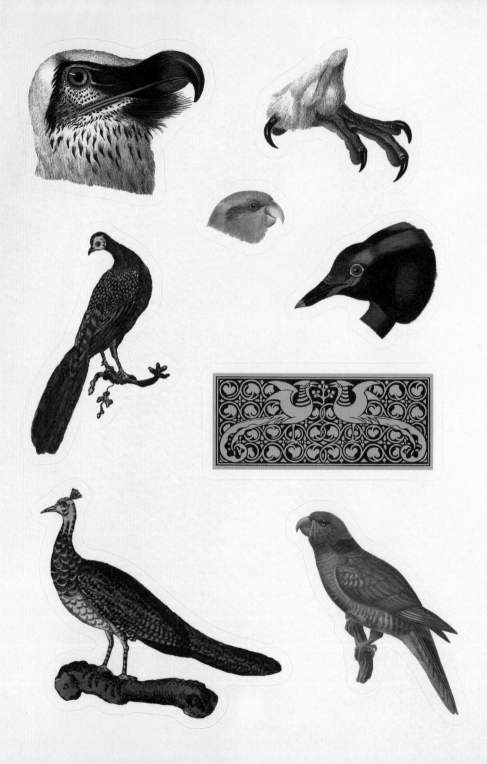

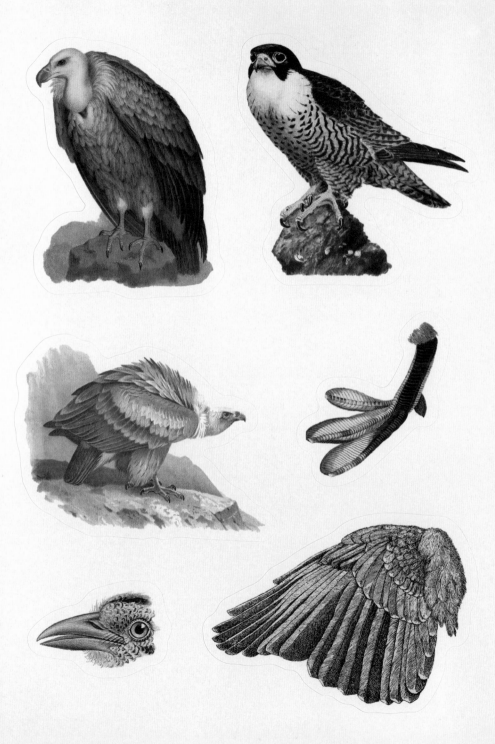

LOCOMOTIVE PASSENGER ENGINE.
GLOBE WORKS BOSTON. JOHN SOUTHER & CO.

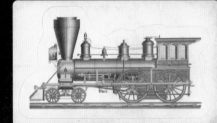

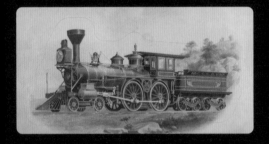

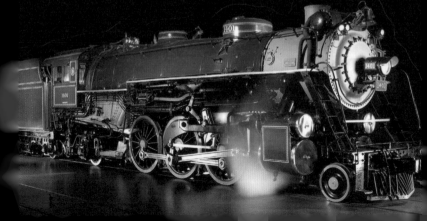

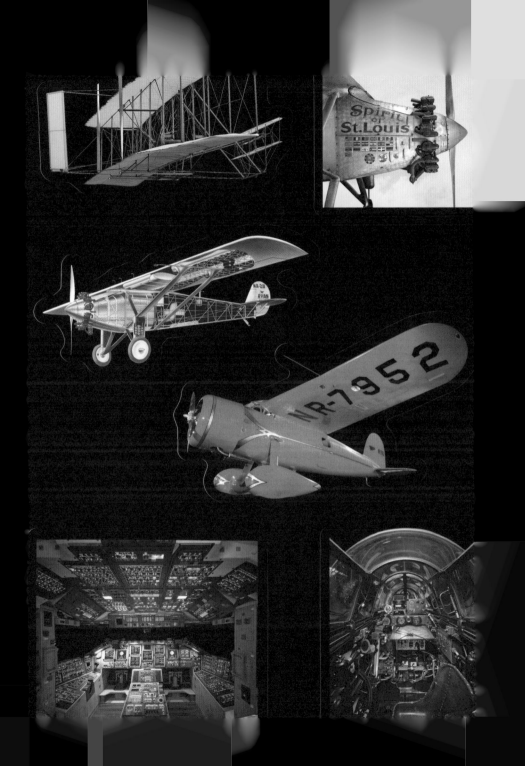

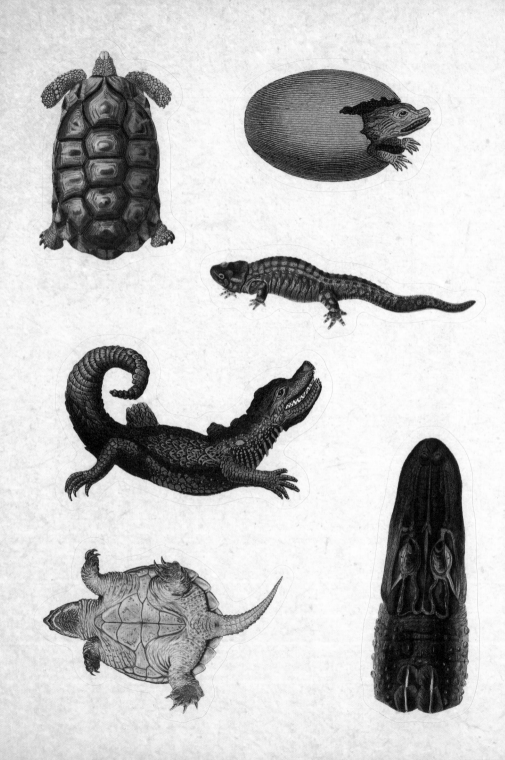

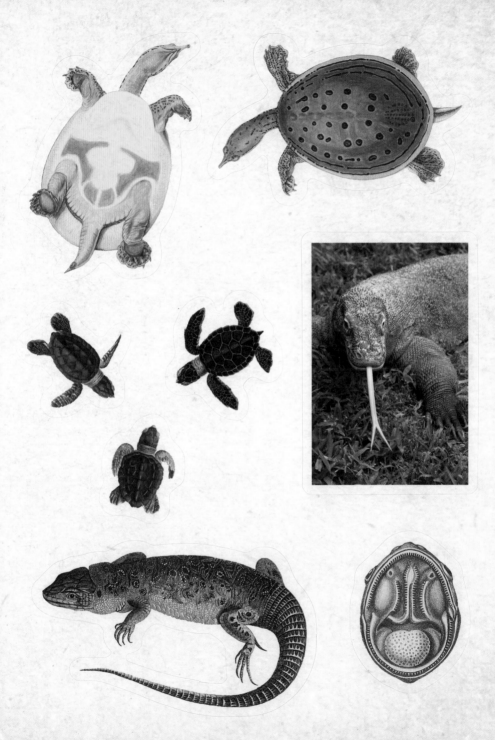

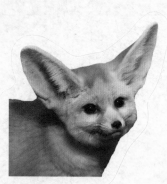

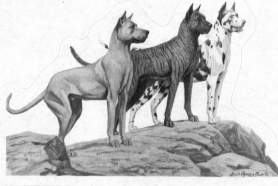

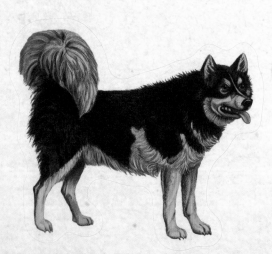

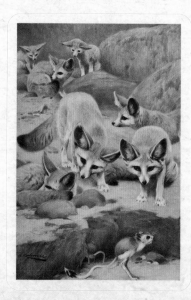

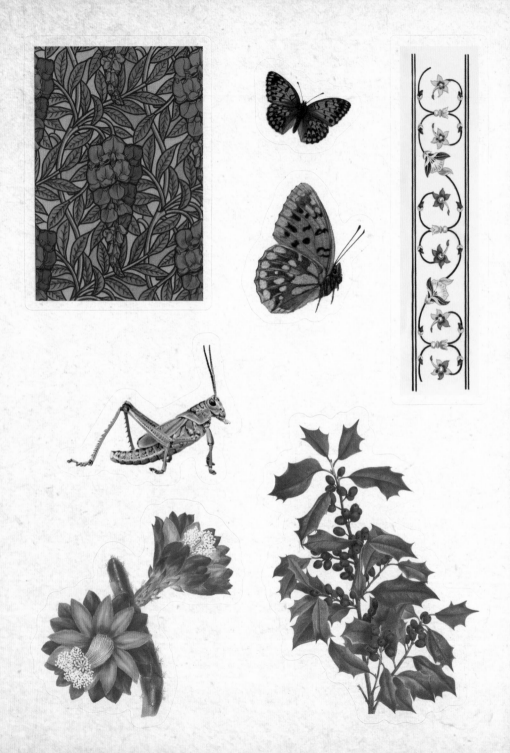

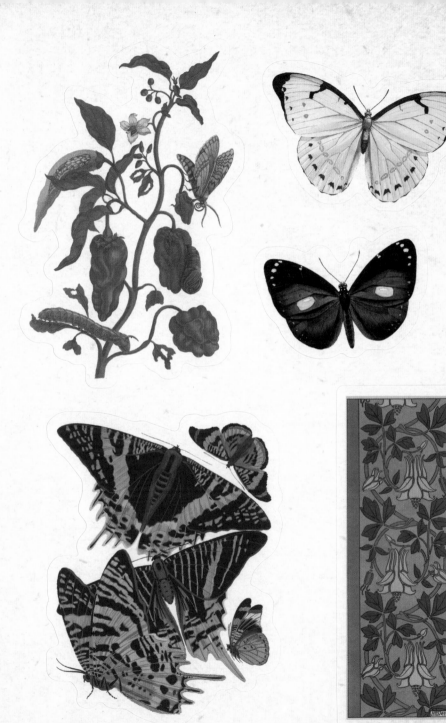

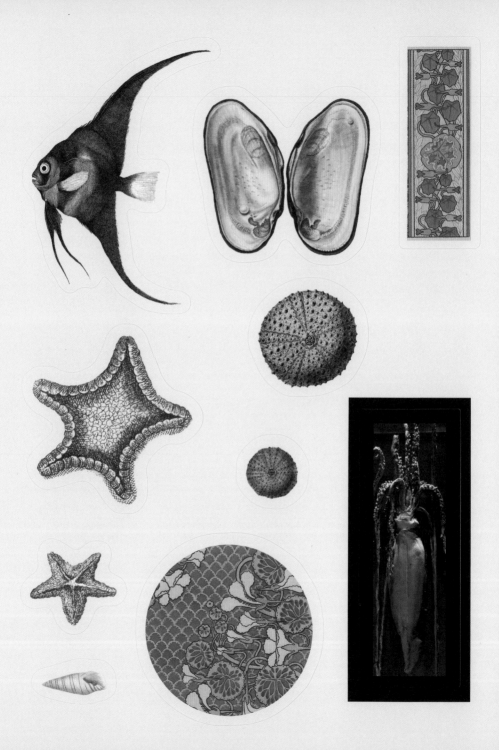

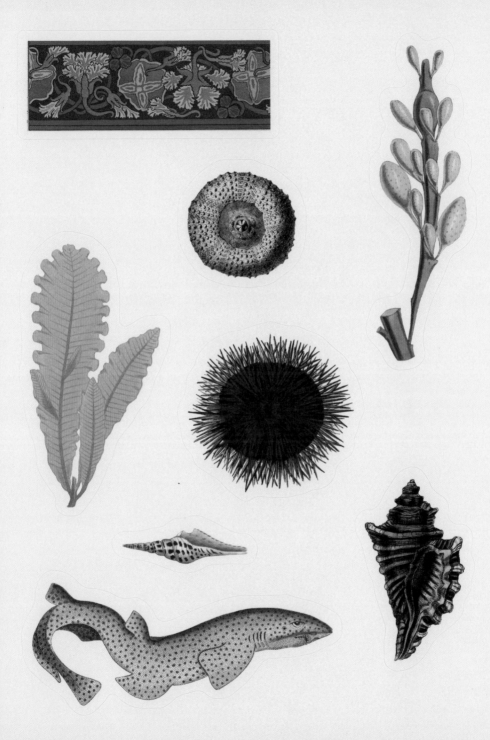

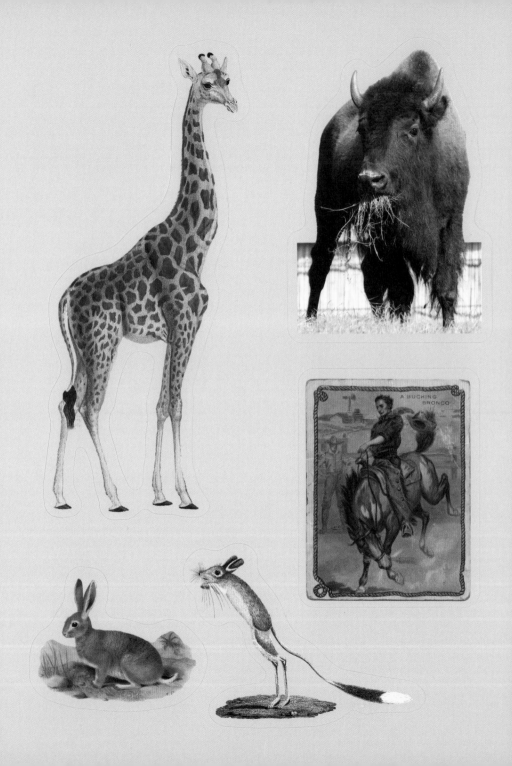

A BUCKING BRONCO

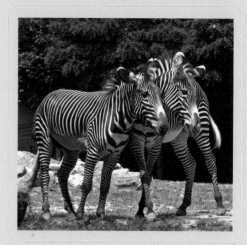

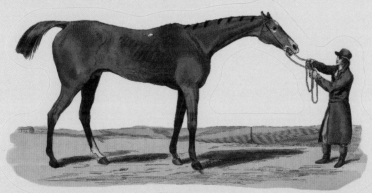

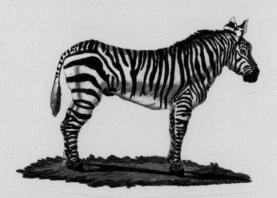

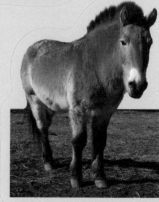

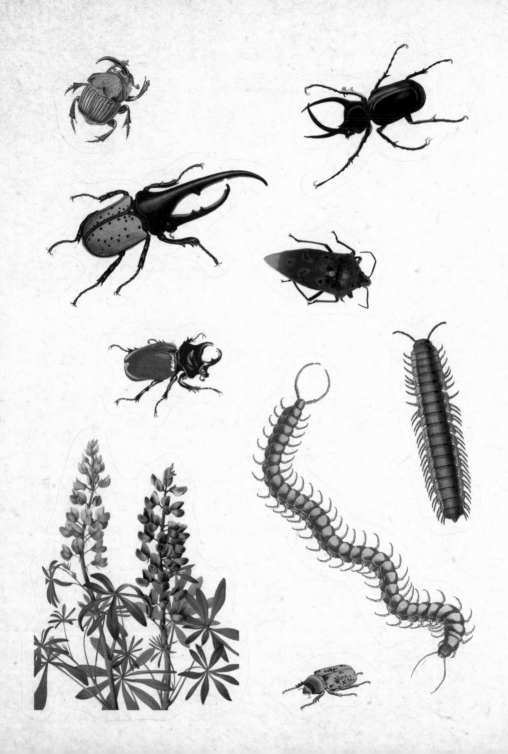

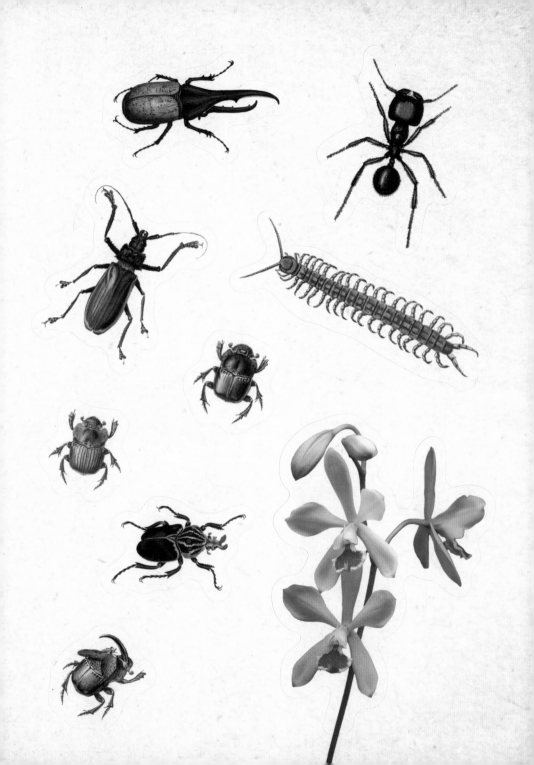

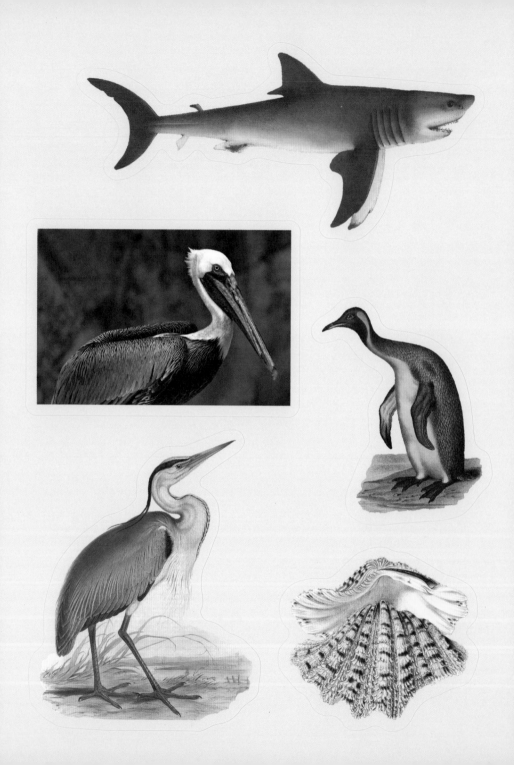

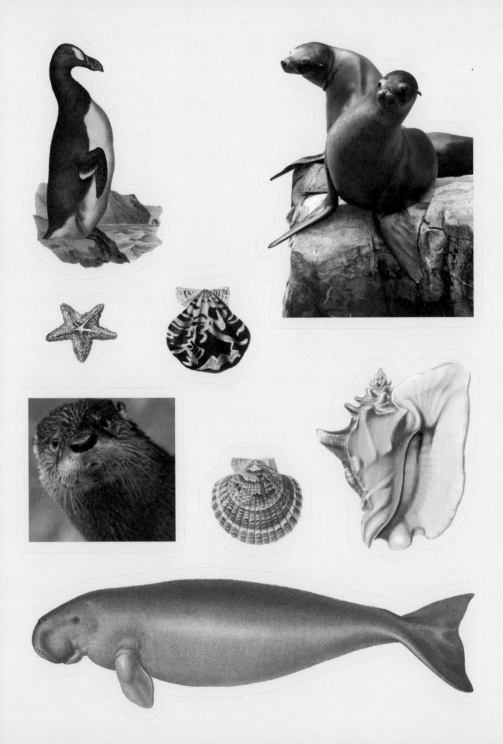

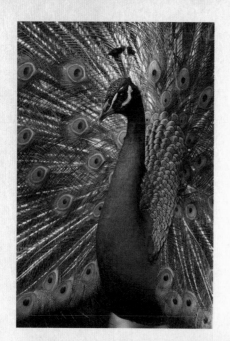
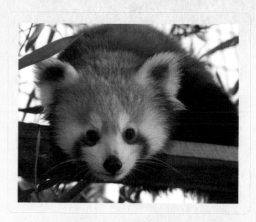
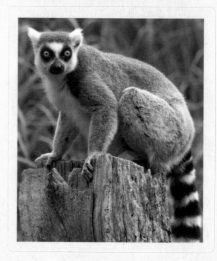
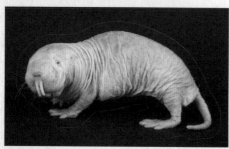
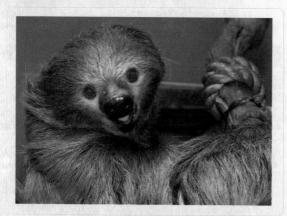

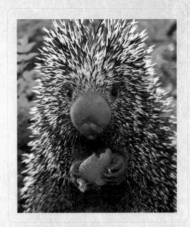

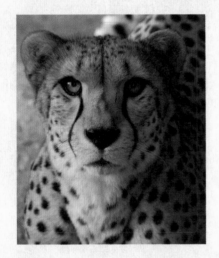

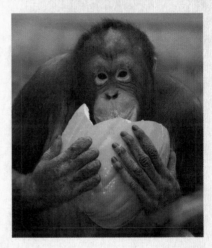

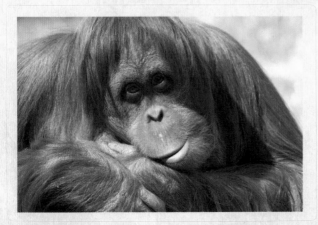

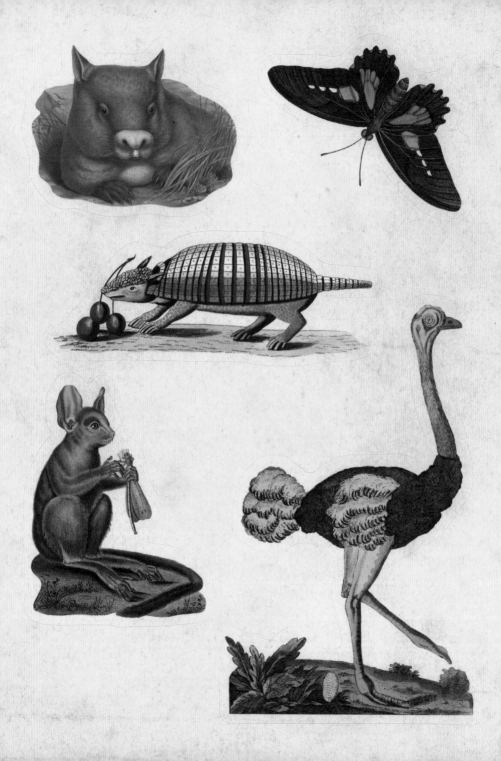

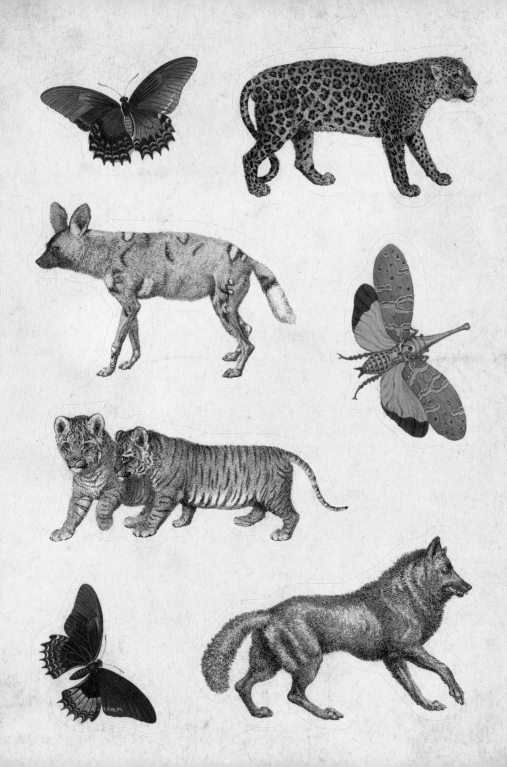

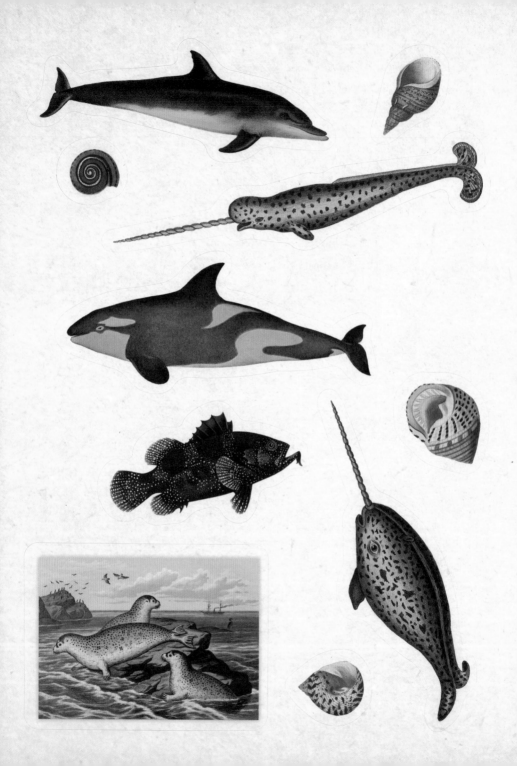

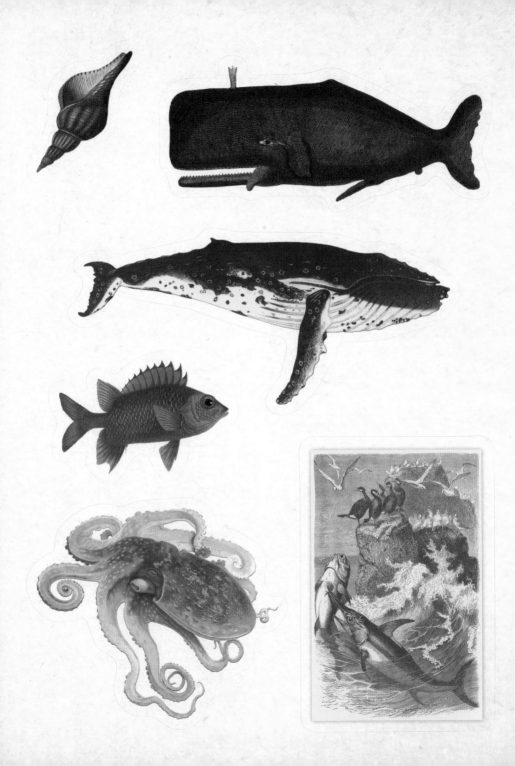

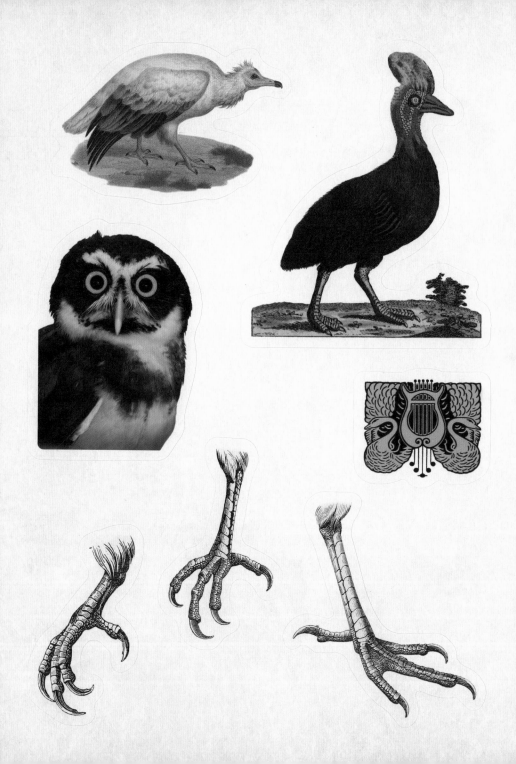

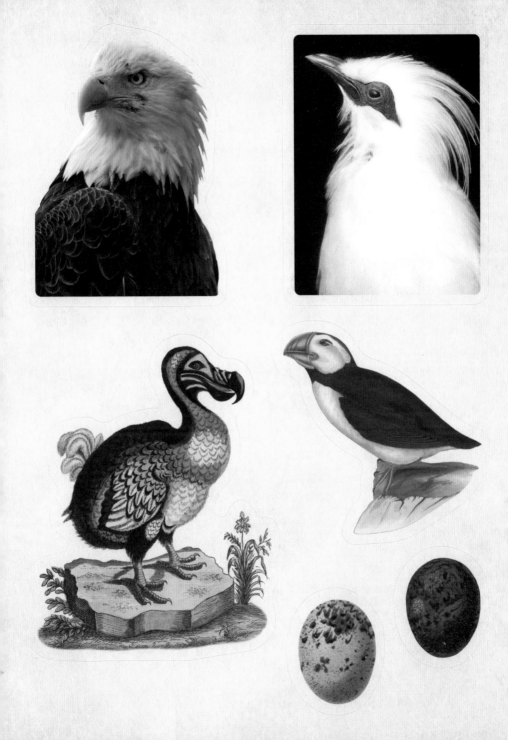

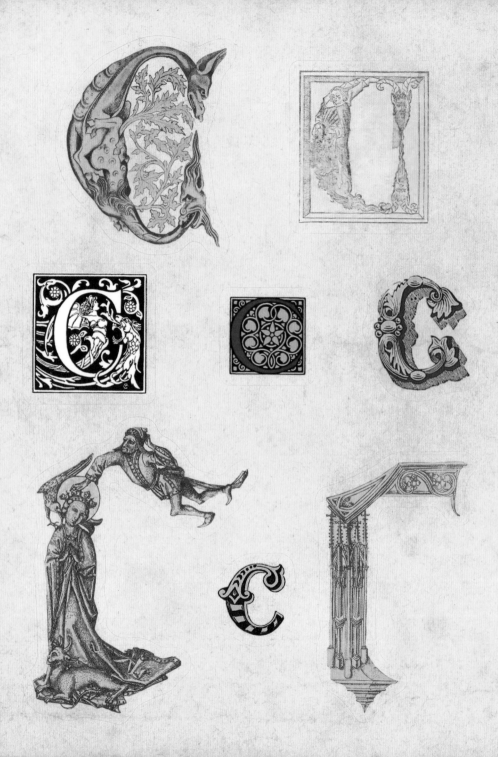

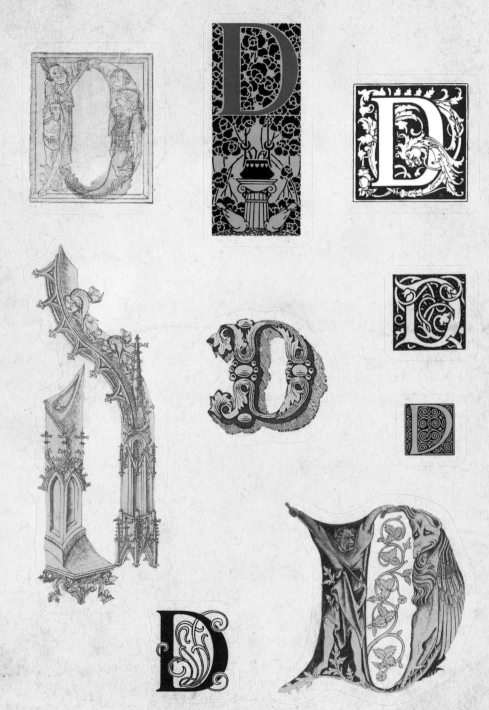

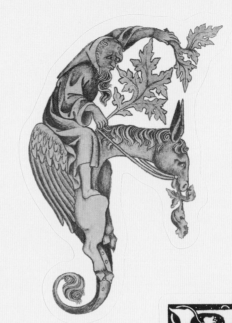

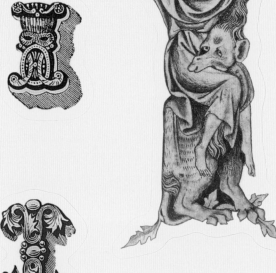

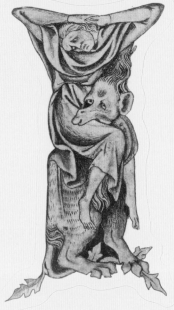

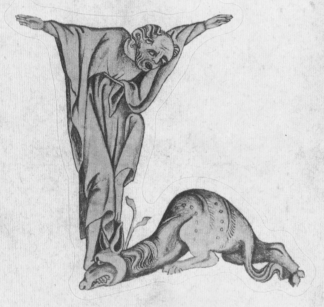

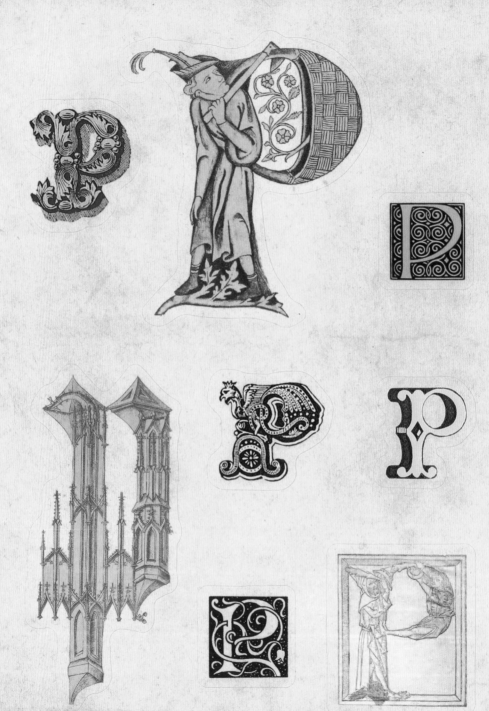

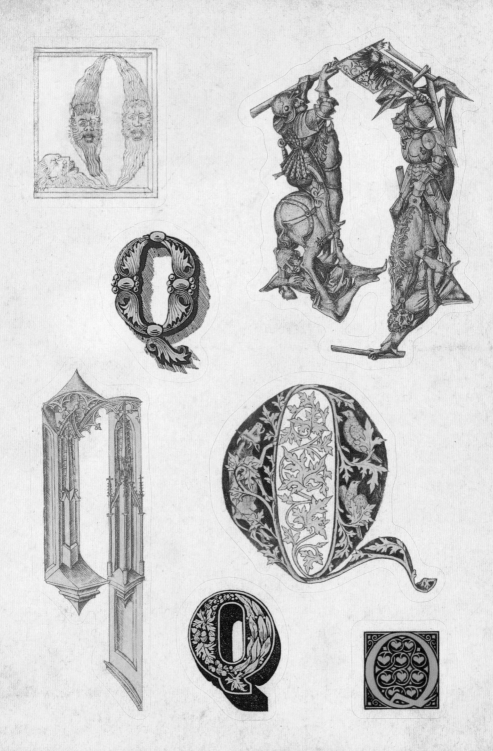

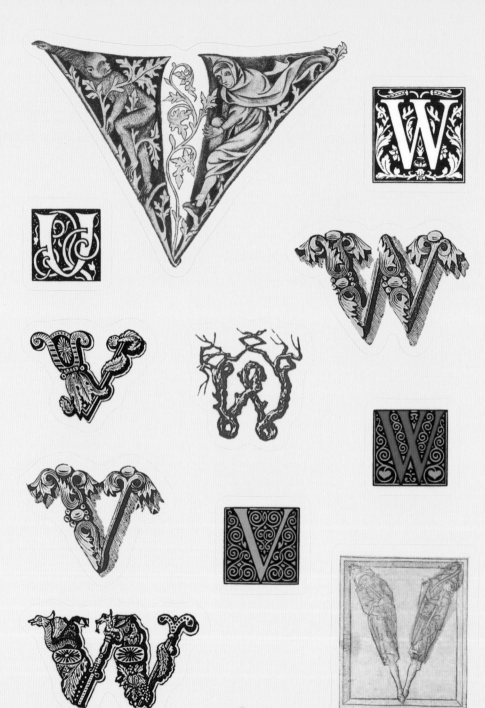

1380

1368

23456

12345678

2 6 5 9 0

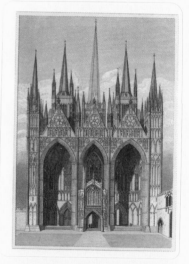

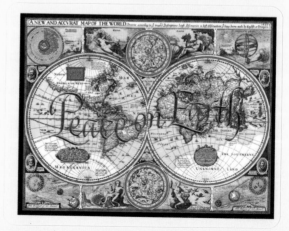

CABINET OF CURIOSITIES

Andrews McMeel Publishing
a division of Andrews McMeel Universal
1130 Walnut Street, Kansas City, Missouri 64106

www.andrewsmcmeel.com

All images courtesy of Smithsonian

22 23 24 25 26 RLP 10 9 8 7 6 5 4 3 2 1

ISBN: 978-1-5248-7215-1

ACKNOWLEDGMENTS

Smithsonian Enterprises: Kealy Gordon, Product Development Manager;
Jill Corcoran, Director, Licensed Publishing; Brigid Ferraro, Vice President,
Business Development and Licensing; Carol LeBlanc, President

Additional thanks to the staff in the Smithsonian Office of Educational Technology
and Paige Towler

ATTENTION: SCHOOLS AND BUSINESSES

Andrews McMeel books are available at quantity discounts with bulk
purchase for educational, business, or sales promotional use. For information,
please e-mail the Andrews McMeel Publishing Special Sales Department:
specialsales@amuniversal.com.